BODYWORKS

A VISUAL GUIDE TO DRAWING THE FIGURE

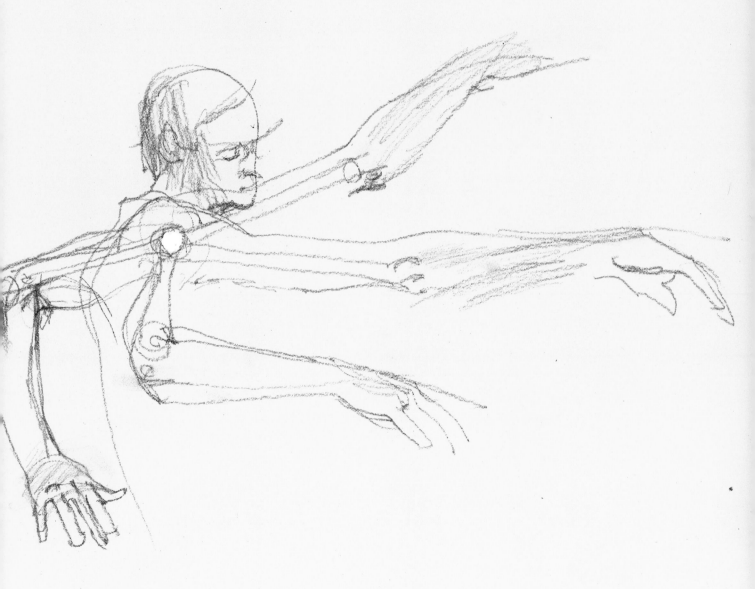

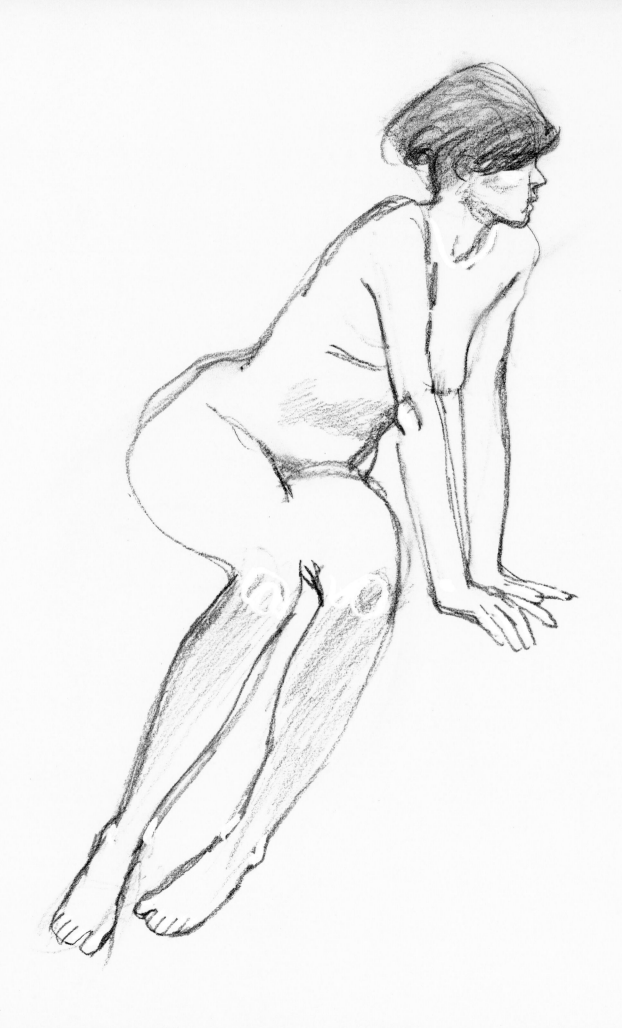

BODYWORKS

A VISUAL GUIDE TO DRAWING THE FIGURE

MARBURY HILL BROWN

NORTH
LIGHT
BOOKS

Cincinnati, Ohio

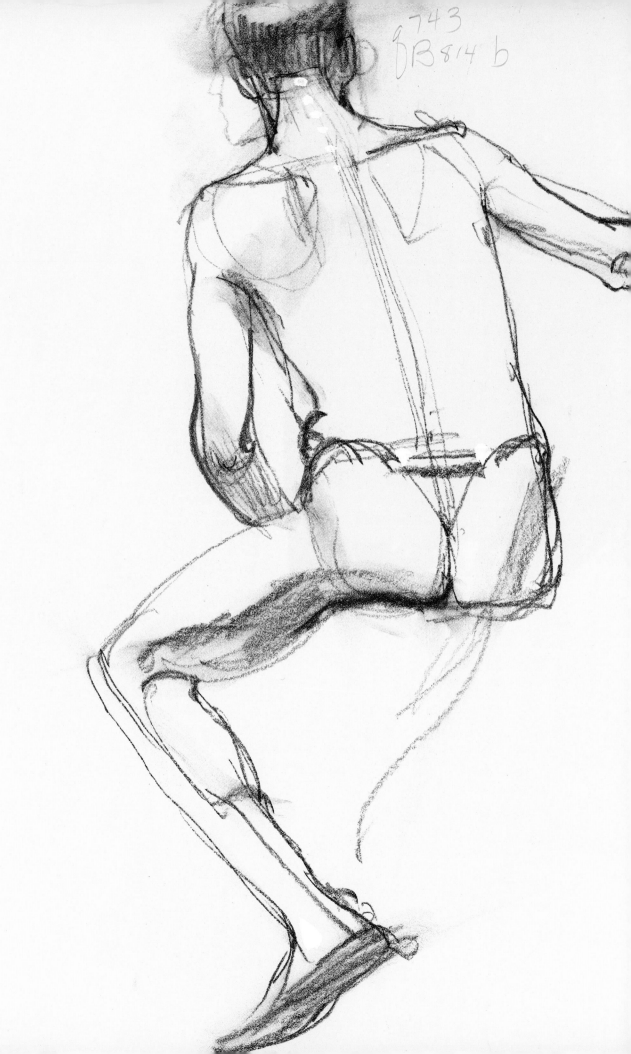

9743
8B814 b

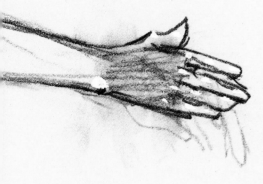

Bodyworks: A Visual Guide to Drawing the Figure. Copyright © 1990 by
Marbury Hill Brown. Printed and bound in the United States of America. All
rights reserved. No part of this book may be reproduced in any form or by any
electronic or mechanical means including information storage and retrieval
systems without permission in writing from the publisher, except by a reviewer,
who may quote brief passages in a review. Published by North Light Books, an
imprint of F&W Publications, Inc., 1507 Dana Avenue, Cincinnati, Ohio 45207.
First edition.

94 93 92 91 90 5 4 3 2 1

Library of Congress Cataloging in Publication Data

Brown, Marbury Hill
 Bodyworks: a visual guide to drawing the figure / by Marbury Hill Brown.
 p. cm.
 ISBN 0-89134-339-3
 1. Human figure in art. 2. Drawing – Technique. I. Title
NC765.B78 1990
743˙.4--dc20 89-70998
 CIP

ACKNOWLEDGMENTS

My method of teaching figure drawing suggested in this book has been established over many years. In 1947 I was blessed with the consistent quality teaching of Herbert Jepson and Rico Lebrun of the Jepson Art Institute, and then later, Wallace Rosenbauer and Mary Fife of the Kansas City Art Institute. This, then, is a compilation of what I have learned and observed through those years.

I would like to express my appreciation to those who directly contributed to the development of this book. First, to Peter Brown who helped me organize my notes and thoughts into a readable order. Second, to my wife, Dorothy, for being a consistent critic, always demanding quality. To Betty Jardine who not only served as the perfect typist but kept asking me for more! To Greg Albert, my editor, who gave me his enthusiastic support and encouragement.

Thanks also to the models whose invaluable help made the book possible: Wayne Eason, Laurie Gordon, Aristotle Georgio, Michele Lombardo, Sandra Howell, Christy Hamel, and Timothy Brown.

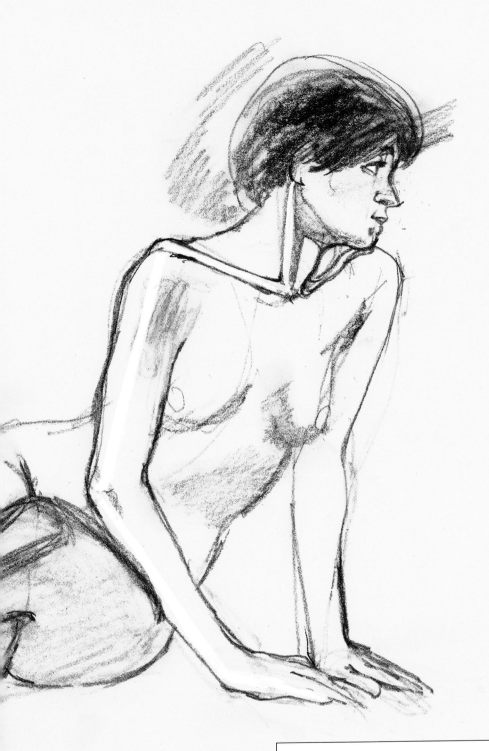

DEDICATION

I dedicate this book to my wife Dorothy Lahey Brown for her invaluable help, unfailing patience, and insistence on quality.

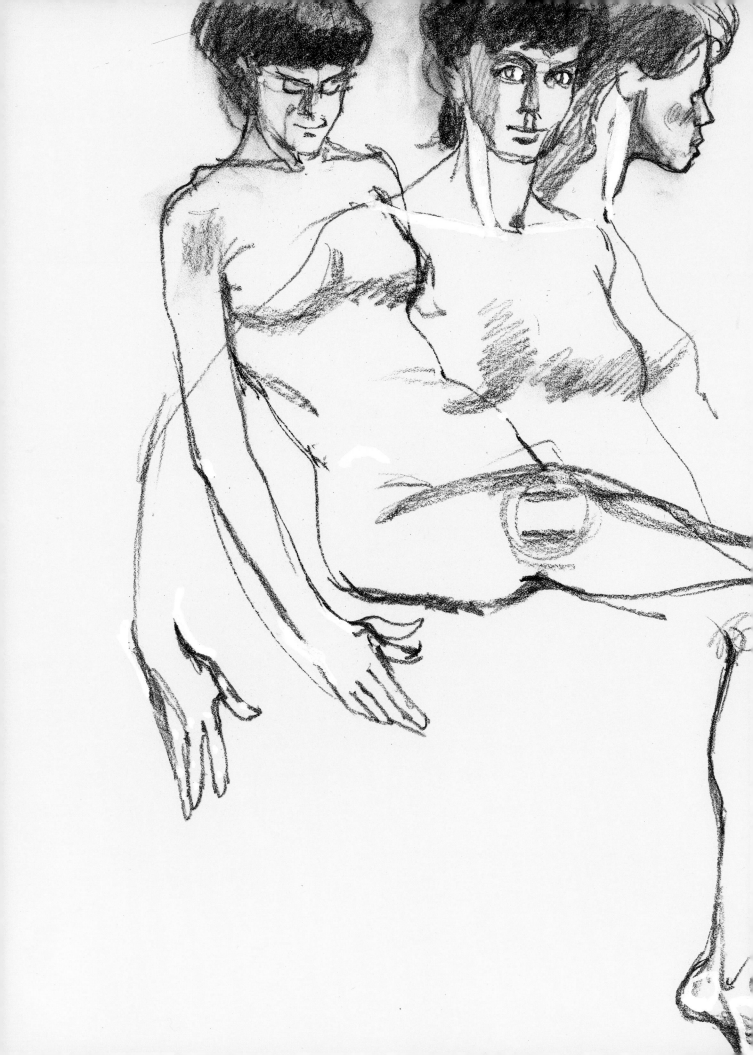

<div style="text-align:center">**CONTENTS**</div>

INTRODUCTION

INTRODUCTION

Learning to see and draw the human figure is a goal of professional and student artists alike. In order to draw the figure correctly, the artist must be able to truly see the human body as it is, not as he might think it is. To really see what he is looking at, the artist must understand what he is looking at. This means knowing how the body works as a unit. It is not enough to be familiar with the details of the parts of the body. The artist must know how all the components of the body work together as a completely unified and integrated organism.

This book is exceptional because it aims to give the artist a real understanding of how the body works as a whole. Wherever possible, the parts of the body are shown incorporated into a complete figure drawing. There is a minimum of disconnected, disjointed bones and muscles gruesomely adorning the pages of this book.

An artist must learn that a finger takes a specific shape in a specific position and that this position is determined by the situation of the hand, the hand by the position of the elbow, the elbow by the shoulder, the shoulder by the spine and head, the spine and head by the location, movement and direction of the hip, legs and feet.

I begin with an overall concept of design, structure, and rhythm. It is a simplified method of describing how the internal structure of the body dictates the external contours of the figure. It is a way for an artist, even in the absence of a model, to visualize and render the human form.

This book is not a textbook to be read, but a picture book to be viewed, enjoyed and studied. An artist learns to draw the figure by drawing with understanding. Giving the artist a visual understanding of the figure is the goal of this book.

Marbury Hill Brown

Marbury Hill Brown

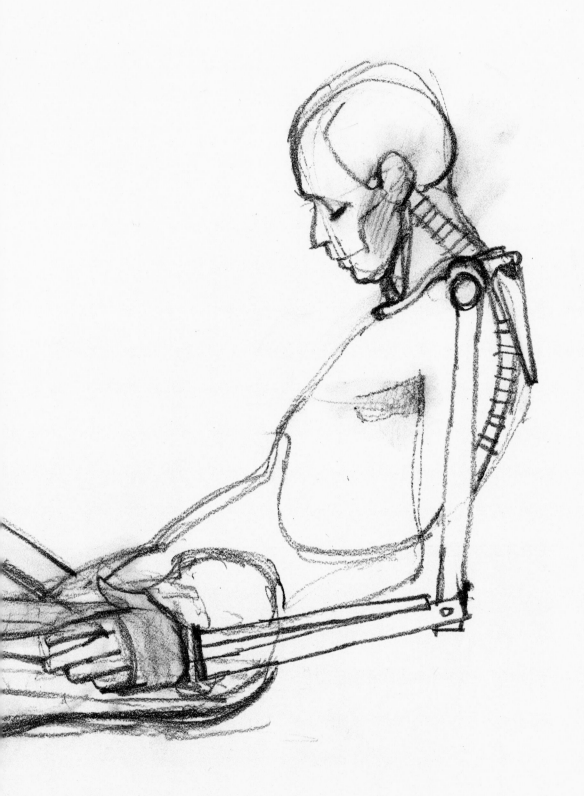

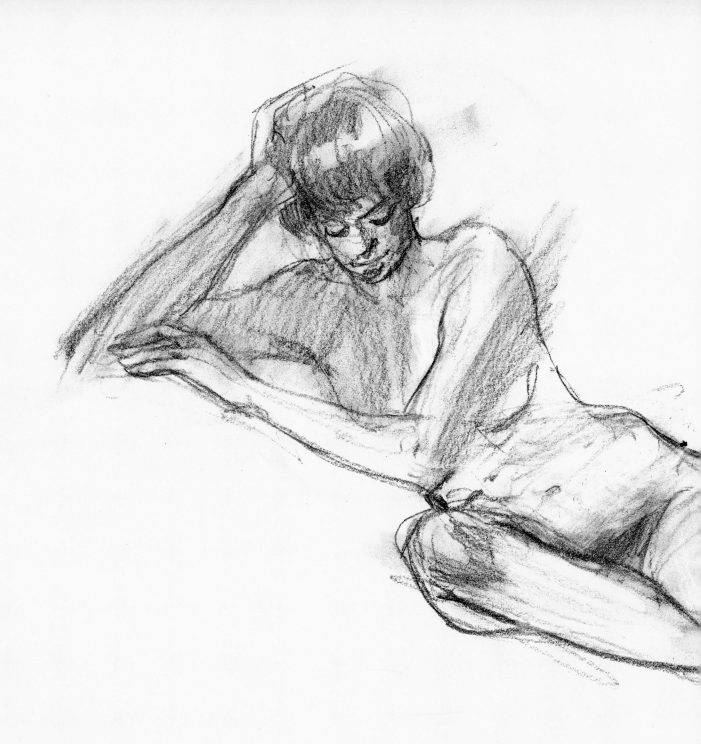

CURVES

What gives the human figure its balance, flexibility and mobility is its design on an "S" curve. The S-curve is constantly visible in the human figure. While a straight line is a rigid and fragile form, a curved shape is capable of flexibility and can manage the crucial task of self-balancing. The drawings here illustrate the profile, front, and back views of bodies shifting weight and the way the "S" controls and allows such actions. It begins at the top of the spine (base of the skull), follows the spine to the pelvis, then emerges at the front of the upper leg to the arch of the foot. The S-shape is also visible when people walk, sit, kneel, lie down, swim, dance, etc.

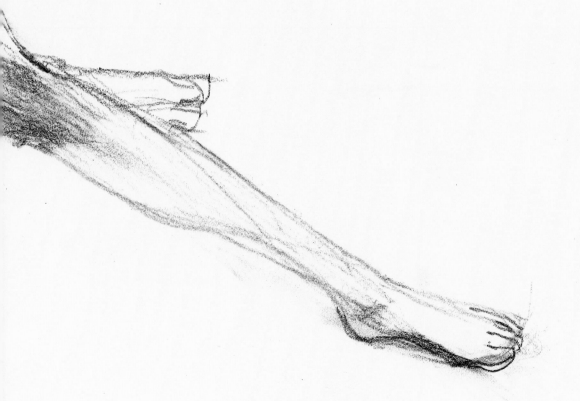

The S-curve that
courses through the
human body gives it
its characteristic
grace and resiliency.
The S-curve acts like
a spring to cushion
the impact of loco-
motion as it counters
the downward pull
of gravity.

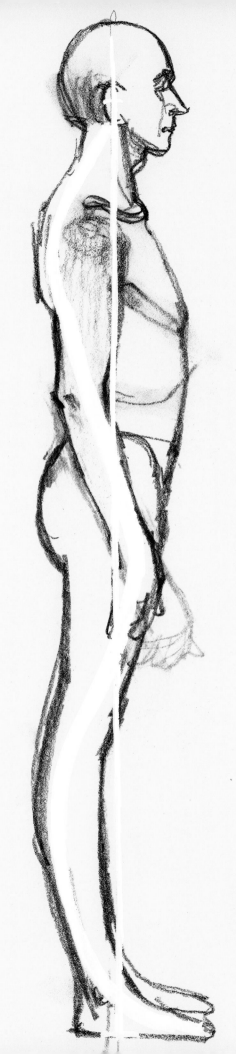

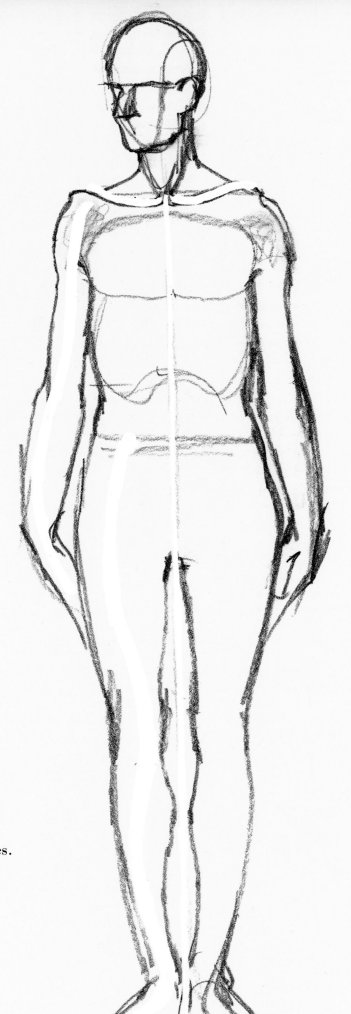

The body exhibits
many examples of
the alternating
rhythm of S-curves.

3

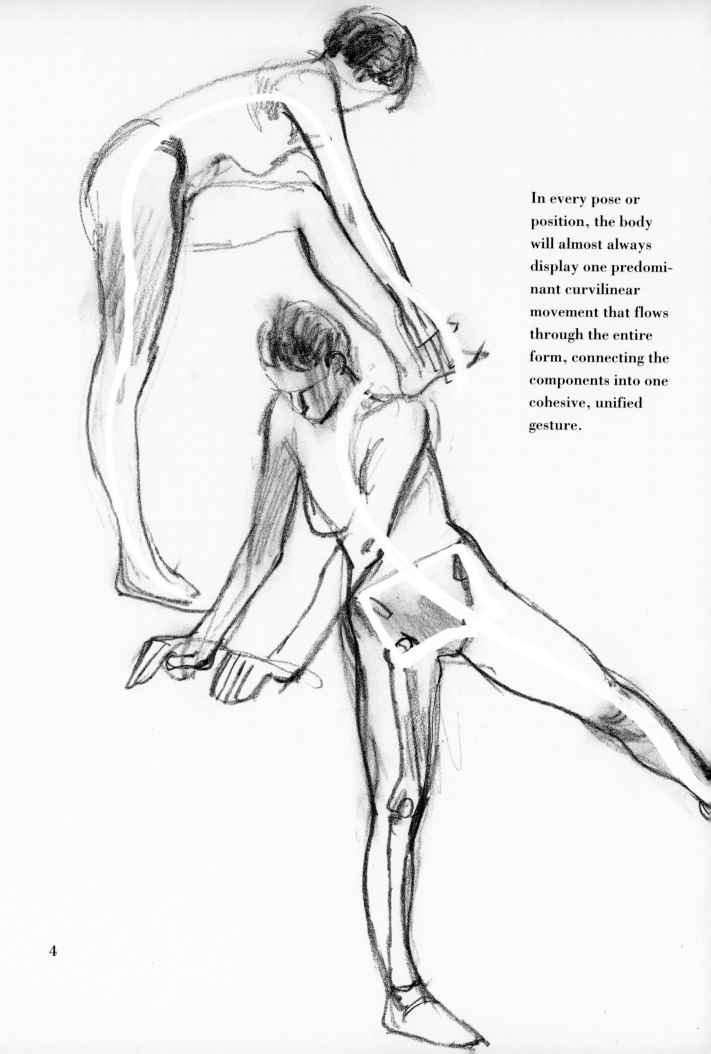

In every pose or position, the body will almost always display one predominant curvilinear movement that flows through the entire form, connecting the components into one cohesive, unified gesture.

4

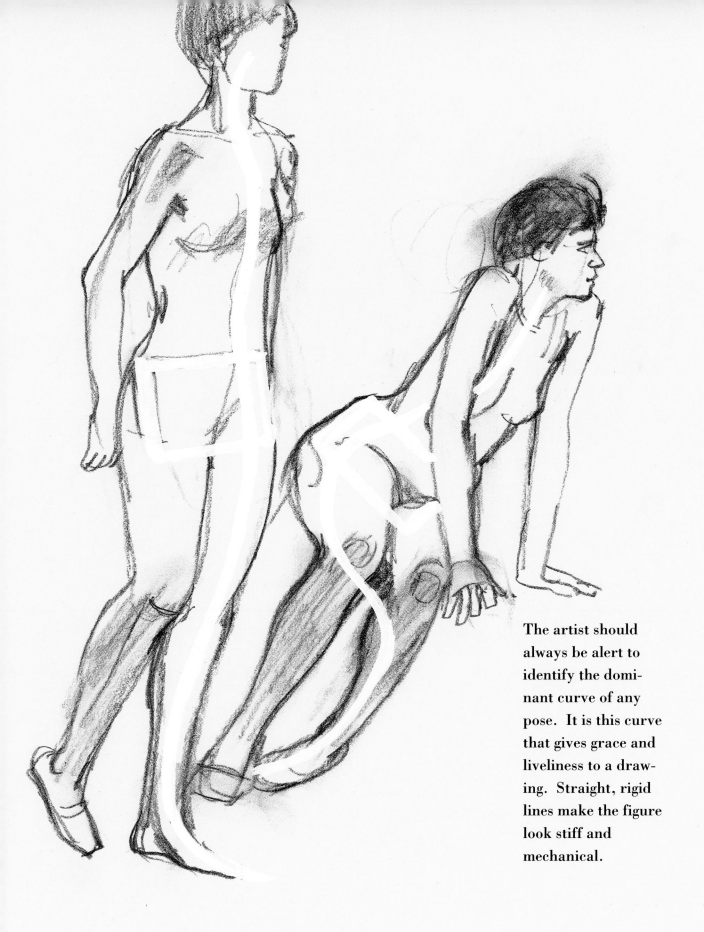

The artist should always be alert to identify the dominant curve of any pose. It is this curve that gives grace and liveliness to a drawing. Straight, rigid lines make the figure look stiff and mechanical.

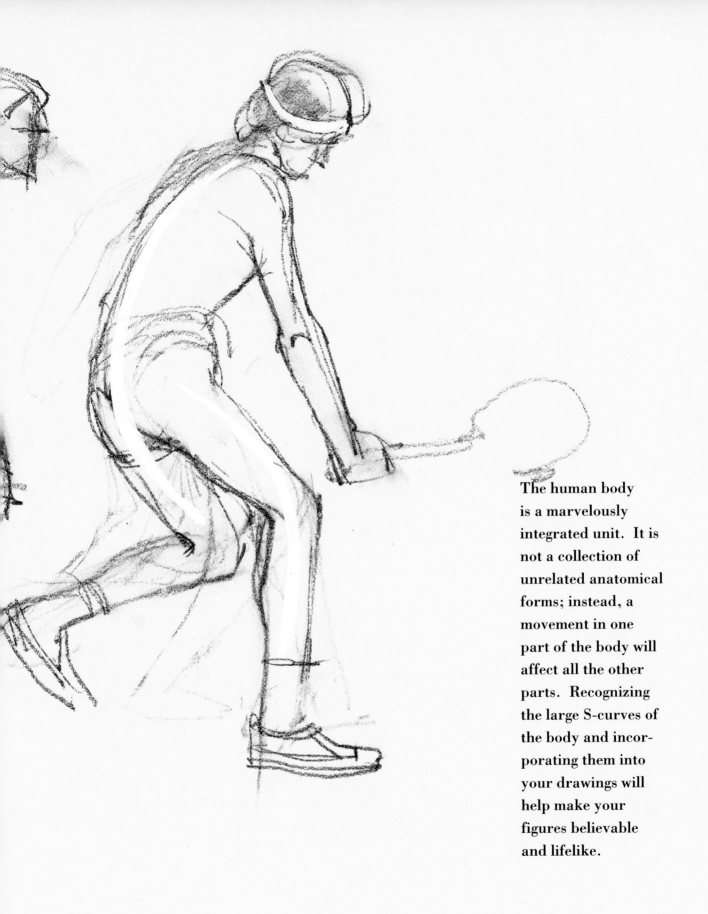

The human body
is a marvelously
integrated unit. It is
not a collection of
unrelated anatomical
forms; instead, a
movement in one
part of the body will
affect all the other
parts. Recognizing
the large S-curves of
the body and incor-
porating them into
your drawings will
help make your
figures believable
and lifelike.

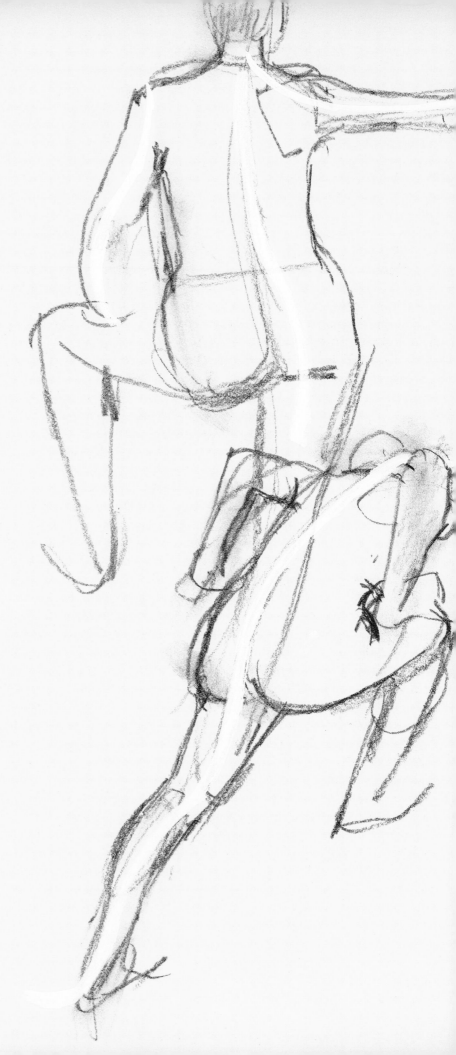

Although the most important S-curve in the body is that of the spine, the rest of the skeleton and the muscle masses echo and enhance its rhythms. Even the muscles and their distribution on the skeleton maintain the alternating rhythm of the S-curve. For instance, the large muscle mass of the thigh is found toward the front of the body, while the large muscle of the lower leg, the calf muscle, is placed in back, thus maintaining the alternating pattern of curves.

8

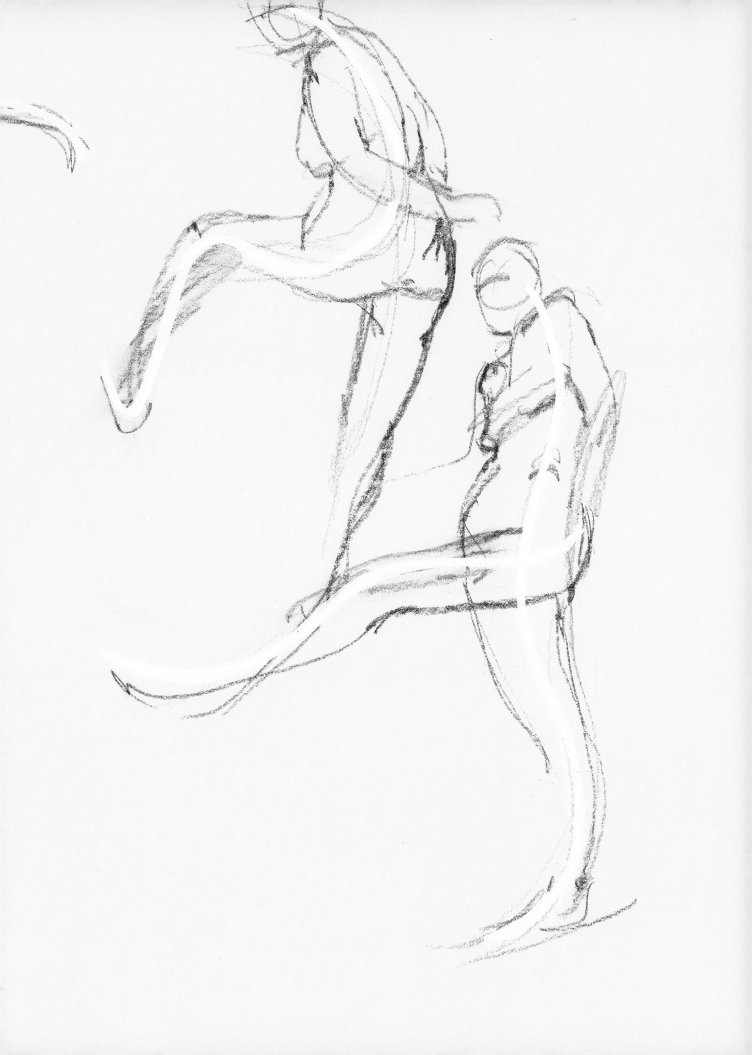

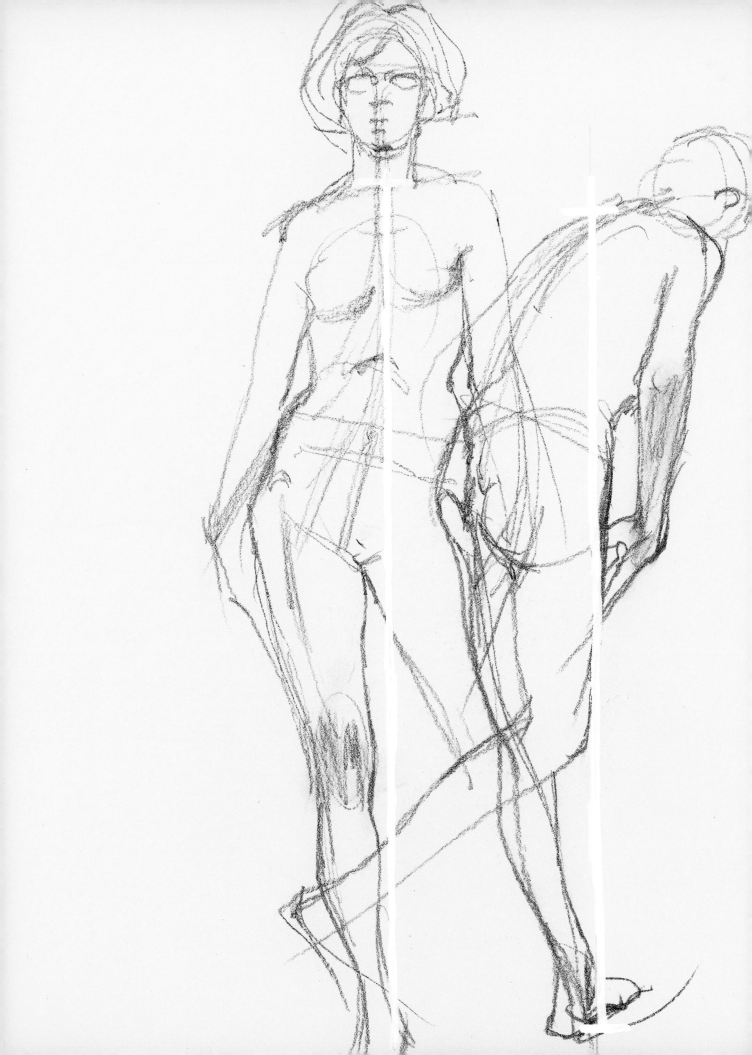

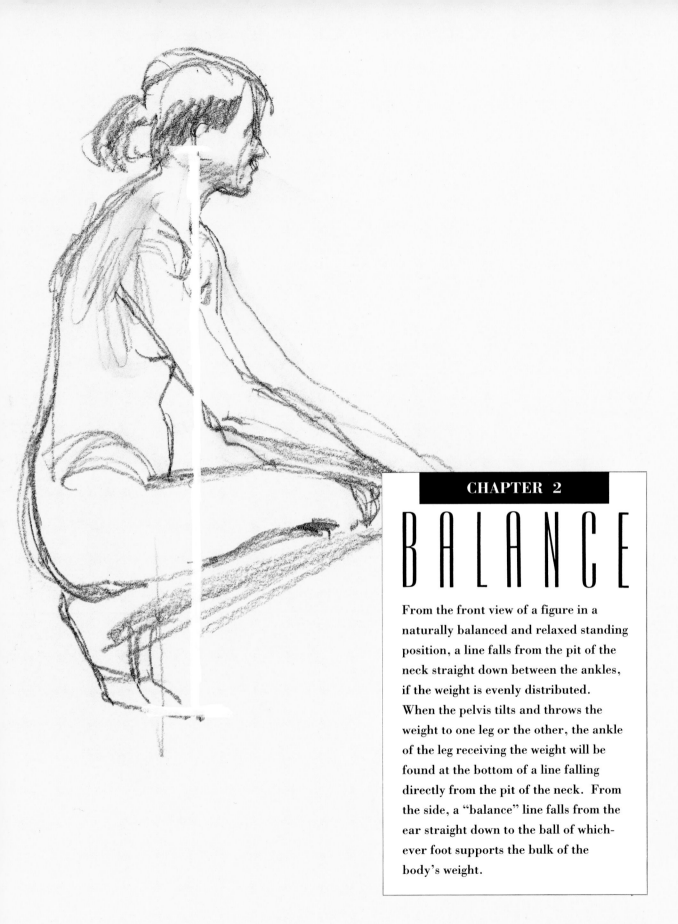

CHAPTER 2

BALANCE

From the front view of a figure in a
naturally balanced and relaxed standing
position, a line falls from the pit of the
neck straight down between the ankles,
if the weight is evenly distributed.
When the pelvis tilts and throws the
weight to one leg or the other, the ankle
of the leg receiving the weight will be
found at the bottom of a line falling
directly from the pit of the neck. From
the side, a "balance" line falls from the
ear straight down to the ball of which-
ever foot supports the bulk of the
body's weight.

11

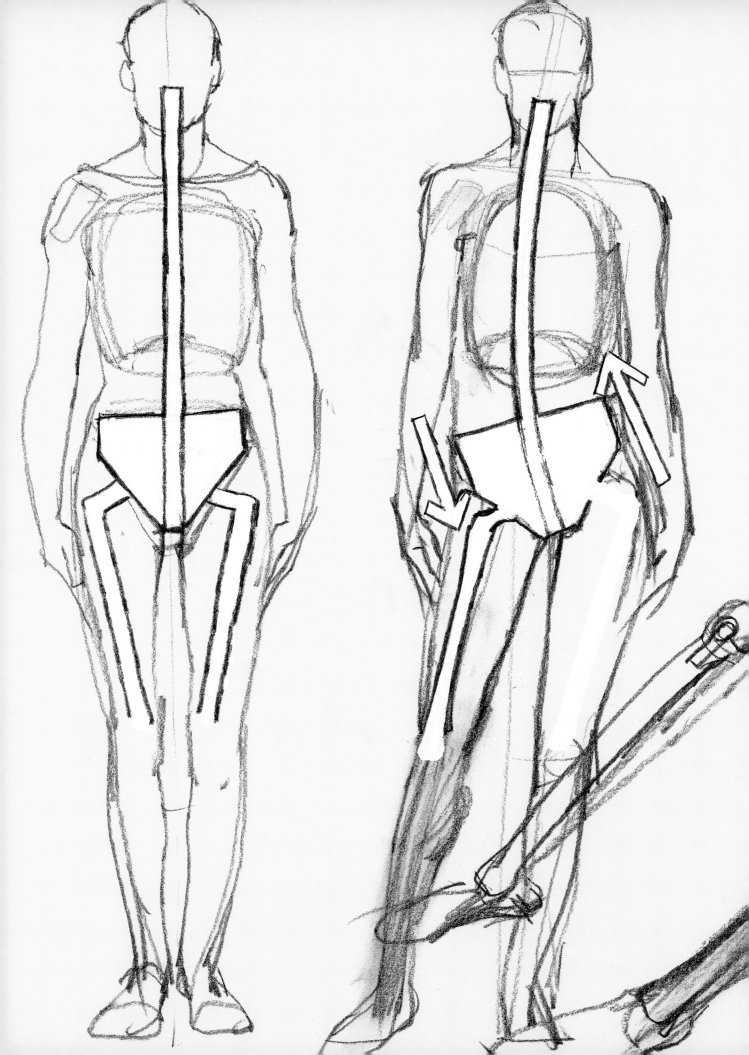

When the weight of the
body is evenly balanced
on the legs, the head, rib
cage, and pelvis align
one on top of the other.
From the front, the
spine appears straight.
When the weight of the
body shifts onto one leg,
the hip of the supporting
leg is thrust out to one
side. Unless the rib cage
and head shift in the
opposite direction to
counter this thrust, the
body will be out of
balance and will begin
to fall.

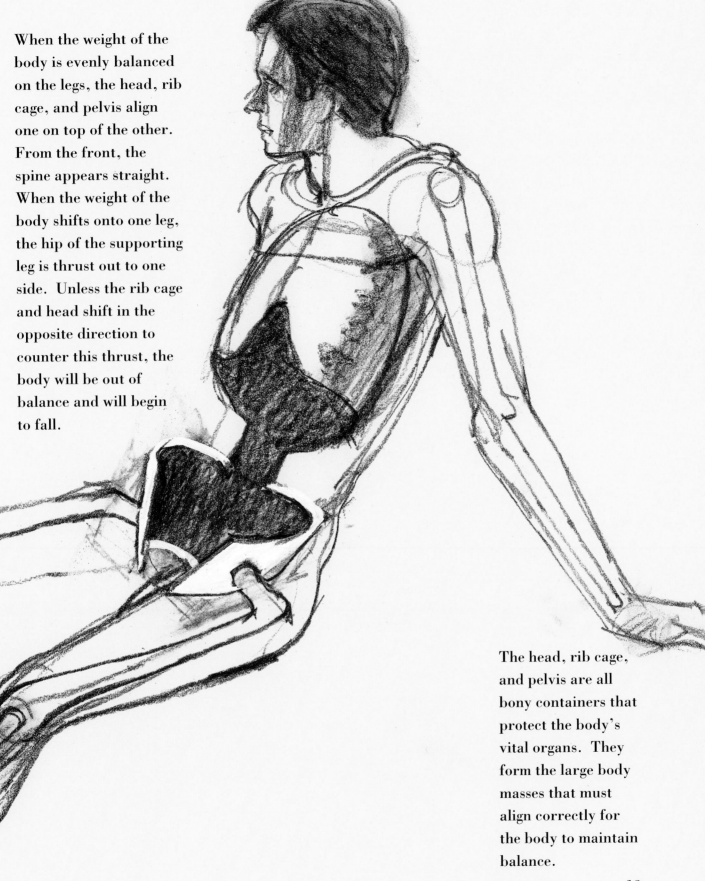

The head, rib cage,
and pelvis are all
bony containers that
protect the body's
vital organs. They
form the large body
masses that must
align correctly for
the body to maintain
balance.

13

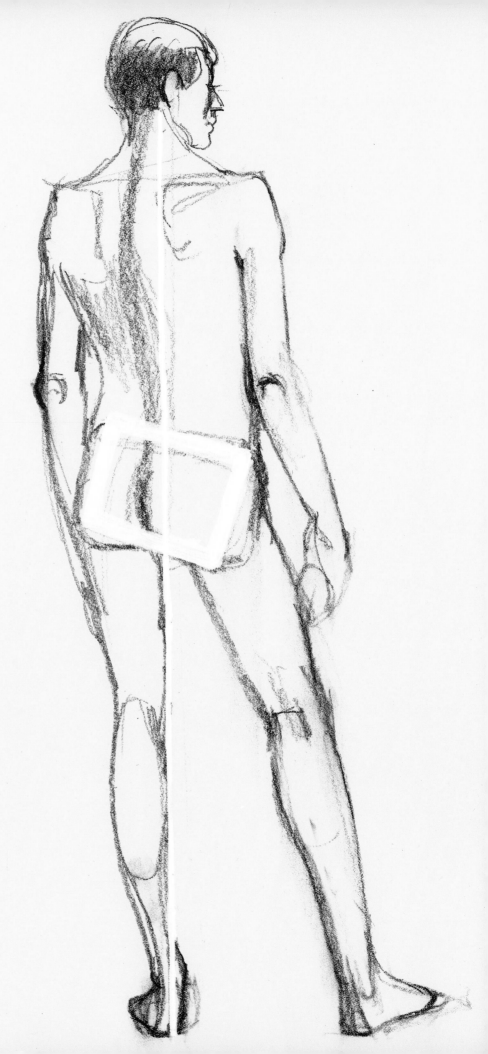

When the weight of the body is supported by one leg, the body masses shift so that the center of gravity is above the supporting leg. If a plumb line were suspended through the center of gravity, it would come to rest directly above the supporting foot.

14

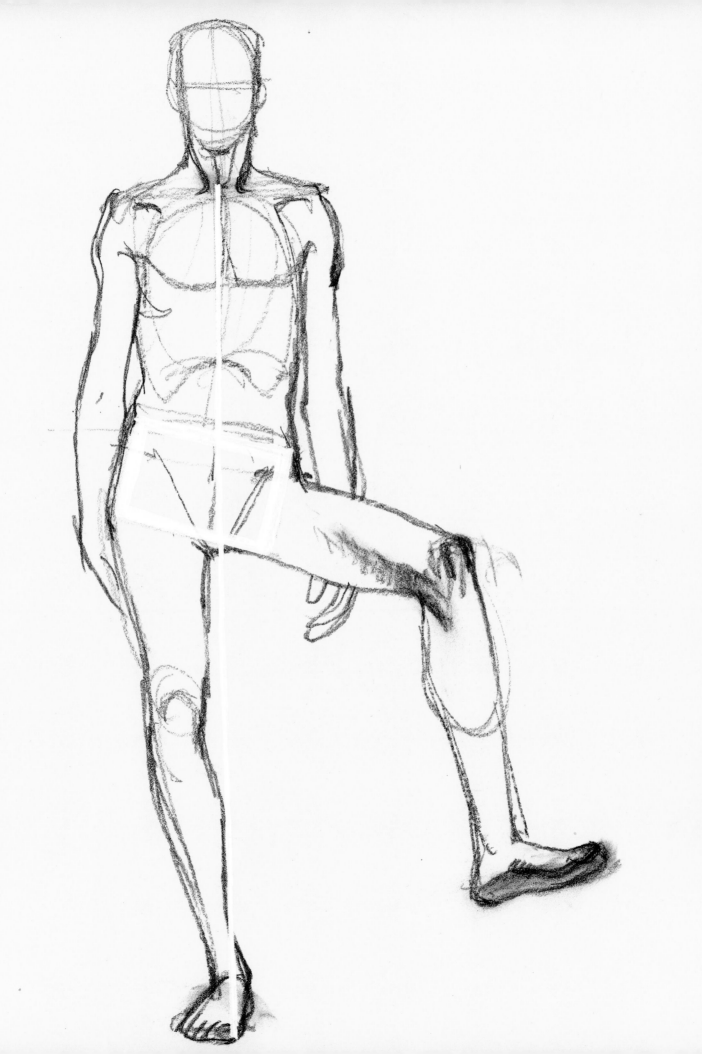

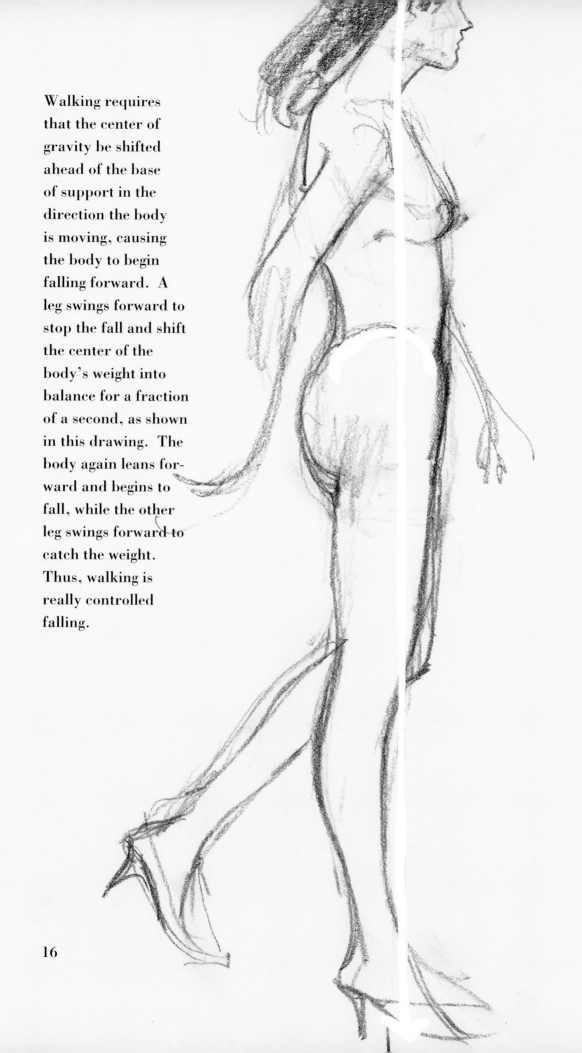

Walking requires
that the center of
gravity be shifted
ahead of the base
of support in the
direction the body
is moving, causing
the body to begin
falling forward. A
leg swings forward to
stop the fall and shift
the center of the
body's weight into
balance for a fraction
of a second, as shown
in this drawing. The
body again leans for-
ward and begins to
fall, while the other
leg swings forward to
catch the weight.
Thus, walking is
really controlled
falling.

16

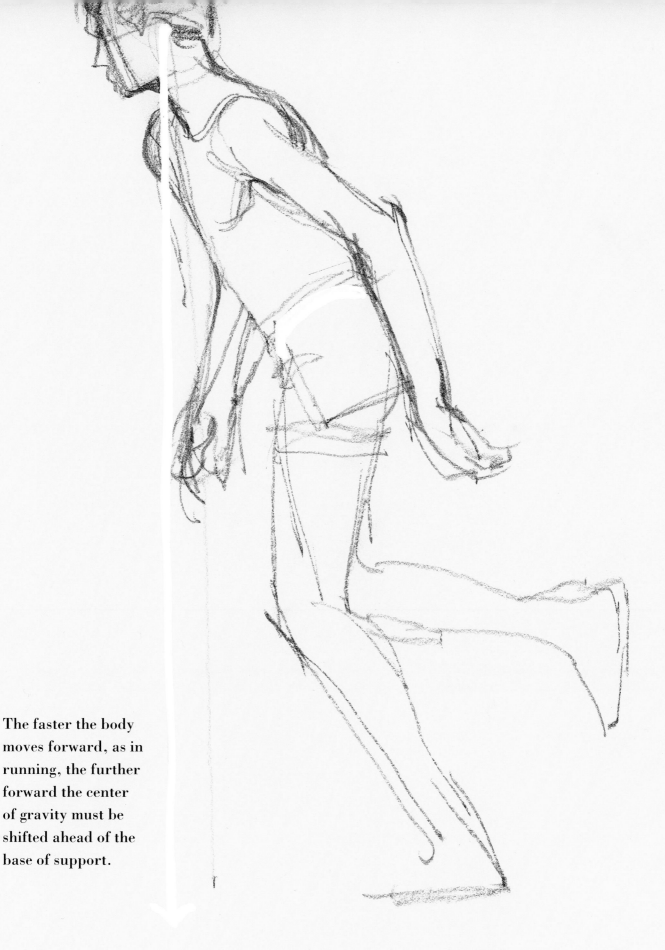

The faster the body moves forward, as in running, the further forward the center of gravity must be shifted ahead of the base of support.

17

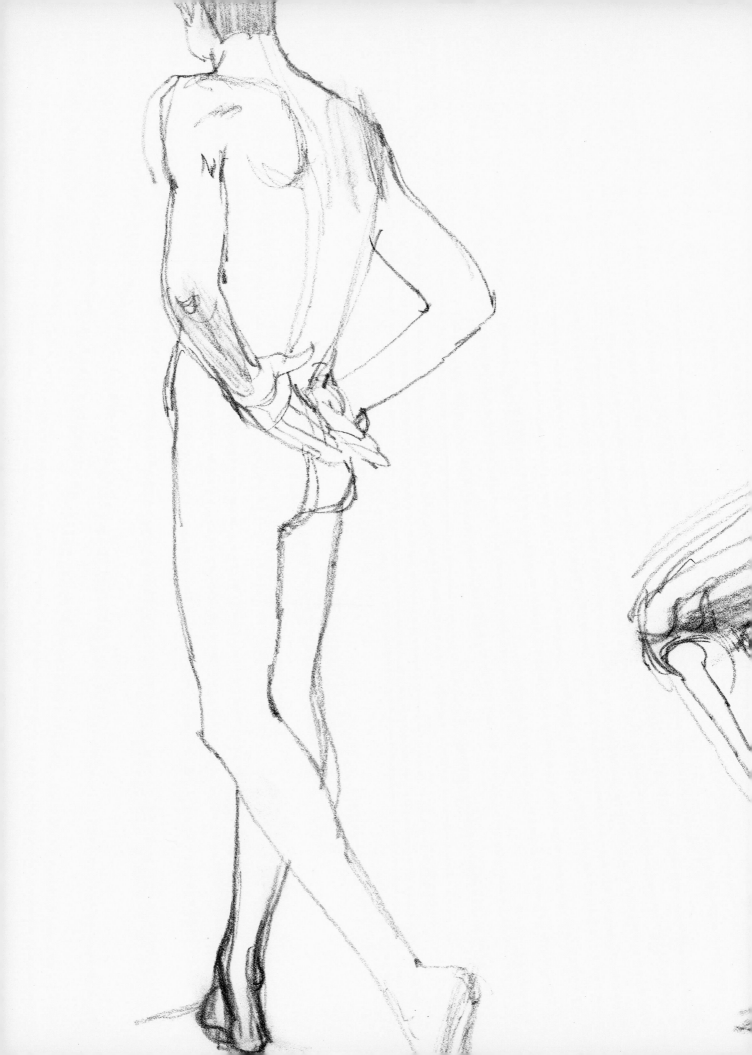

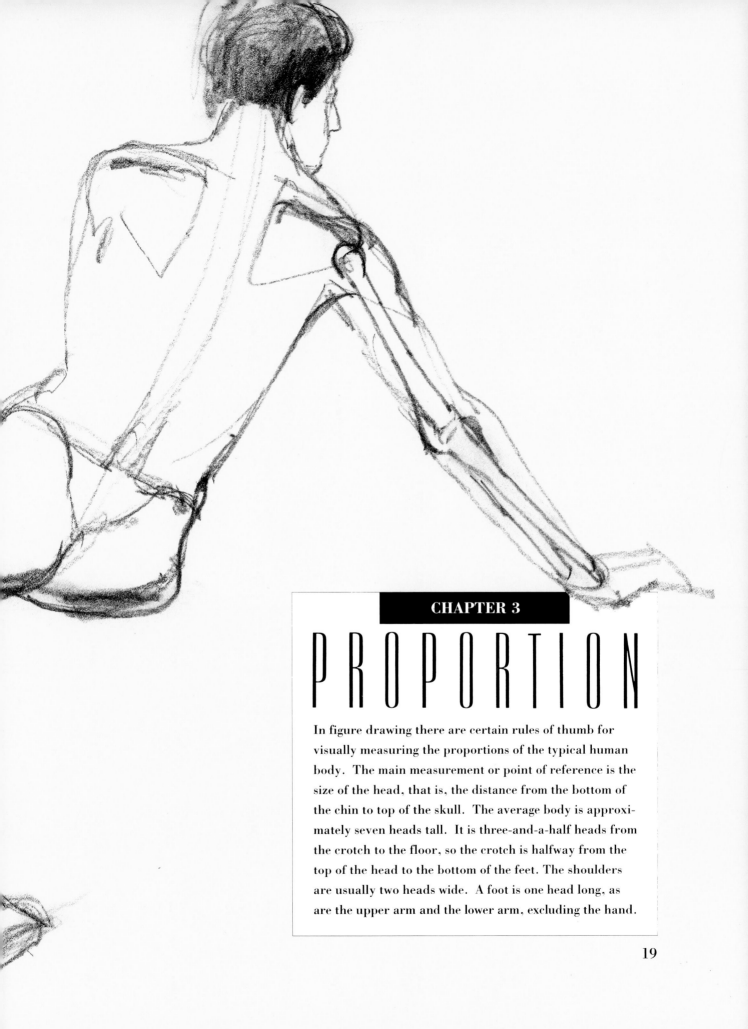

CHAPTER 3
P R O P O R T I O N

In figure drawing there are certain rules of thumb for visually measuring the proportions of the typical human body. The main measurement or point of reference is the size of the head, that is, the distance from the bottom of the chin to top of the skull. The average body is approximately seven heads tall. It is three-and-a-half heads from the crotch to the floor, so the crotch is halfway from the top of the head to the bottom of the feet. The shoulders are usually two heads wide. A foot is one head long, as are the upper arm and the lower arm, excluding the hand.

19

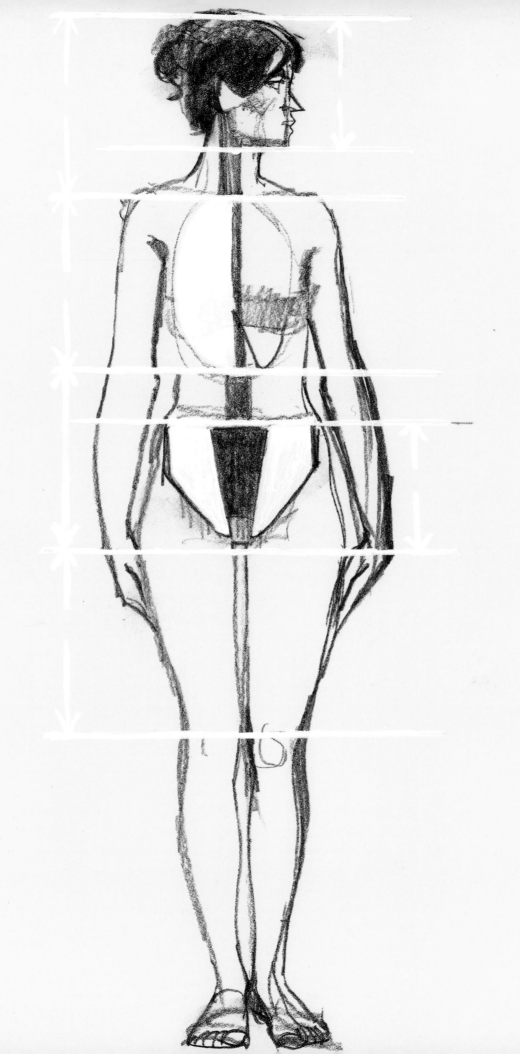

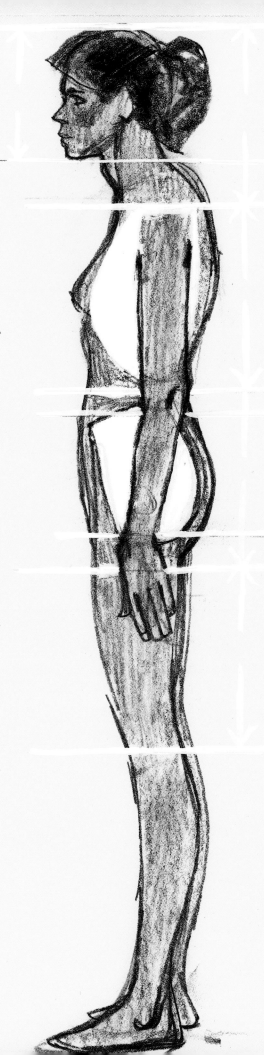

The distances from the top of the head to the top of the rib cage, from the top to the bottom of the rib cage, from the bottom of the rib cage to the crotch, and from the crotch to the knees are equal. The pelvis is one head high.

21

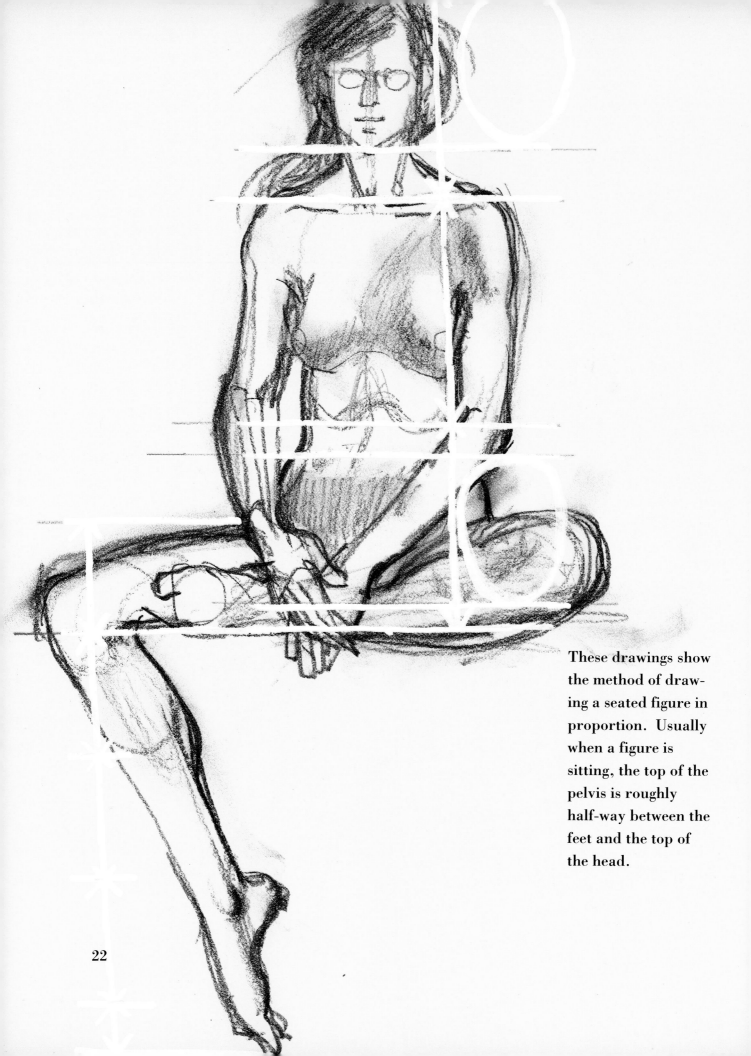

These drawings show the method of drawing a seated figure in proportion. Usually when a figure is sitting, the top of the pelvis is roughly half-way between the feet and the top of the head.

22

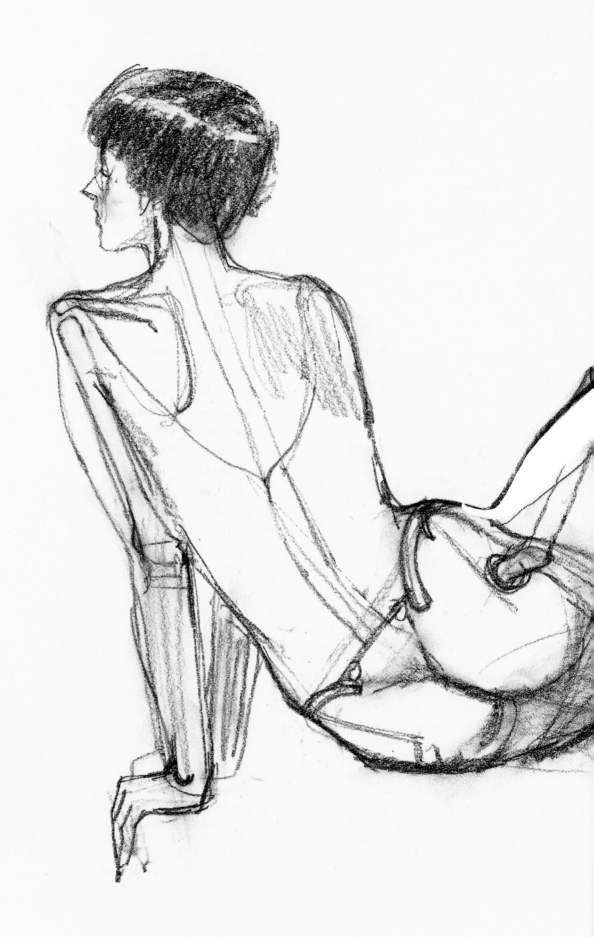

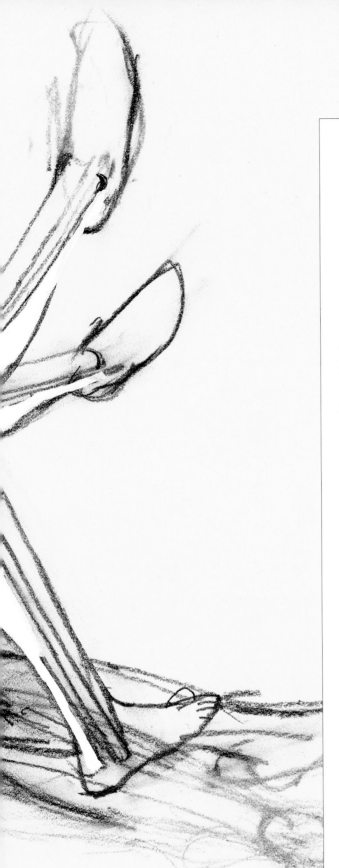

CHAPTER 4

STRUCTURE & TENSION

The skeleton supports and is supported by the muscles. This interrelation creates a system of "tension" which is an arrangement of rigid and flexible parts. The skeleton is as if bound in a suit of rubberbands, which work with and against each other, operating our bones, pulling them back and forth and up and down as we walk, run, move and breathe. The drawings in this chapter include illustrations of muscles joining bones at the elbow and shoulder, pulling from their origin and causing operation of the bones where they insert. The "origin," in this terminology, is the static root of the muscle. It is the point from which the muscle pulls. The "insertion" is where action results. For example, when an arm is flexed, the biceps pulls the insertion, located on the forearm just above the inner elbow, towards its origin at the shoulder and causes movement of the forearm. When an arm is extended, the triceps pulls its insertion, located on the forearm just beyond the outer elbow, towards its origin located behind and below the shoulder. When the triceps is flexed, the biceps is extended. When the biceps is flexed, the triceps is extended. These muscles resemble rubberbands operating opposite each other to give the arm its power and movement.

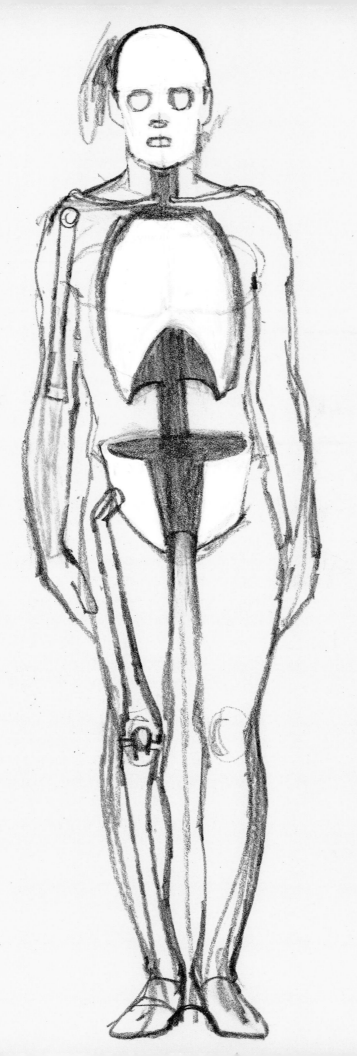

The skeleton forms the inner structure of the body. It is the framework or inner architecture of the human form. The bones that provide protection for the vital organs form container-like masses; the bones that enable bodily motion are long, rigid rods.

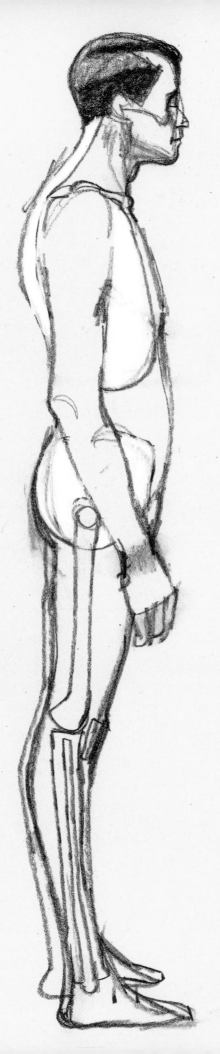

The skeleton is operated by a system of muscles in varying degrees of tension. When opposing muscles are in equal tension, the body is still, as when standing erect. When the tensions are unequal, the body moves.

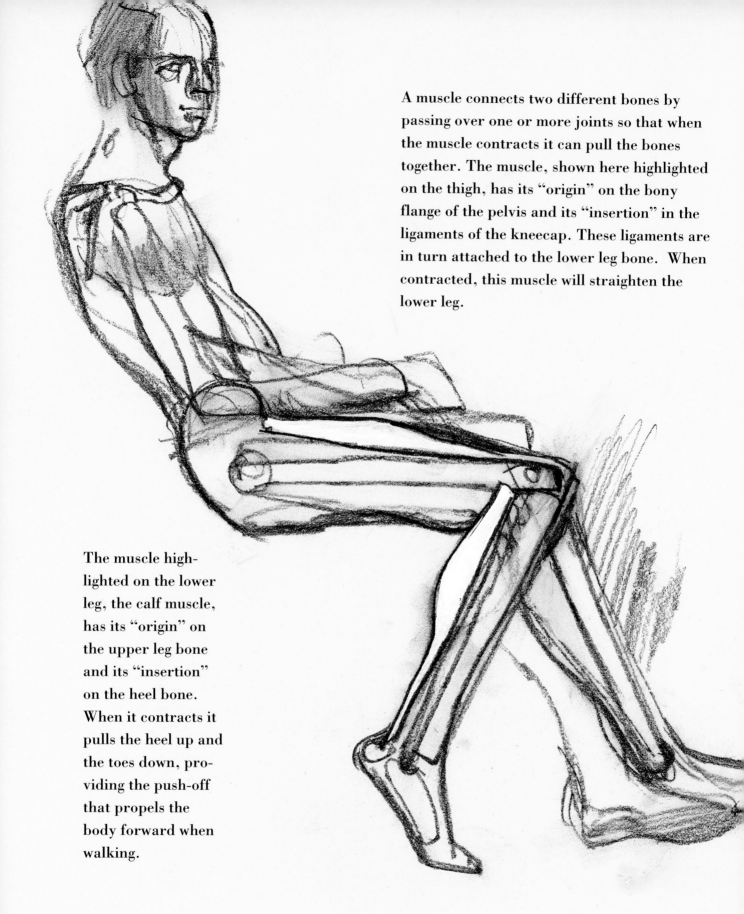

A muscle connects two different bones by passing over one or more joints so that when the muscle contracts it can pull the bones together. The muscle, shown here highlighted on the thigh, has its "origin" on the bony flange of the pelvis and its "insertion" in the ligaments of the kneecap. These ligaments are in turn attached to the lower leg bone. When contracted, this muscle will straighten the lower leg.

The muscle highlighted on the lower leg, the calf muscle, has its "origin" on the upper leg bone and its "insertion" on the heel bone. When it contracts it pulls the heel up and the toes down, providing the push-off that propels the body forward when walking.

28

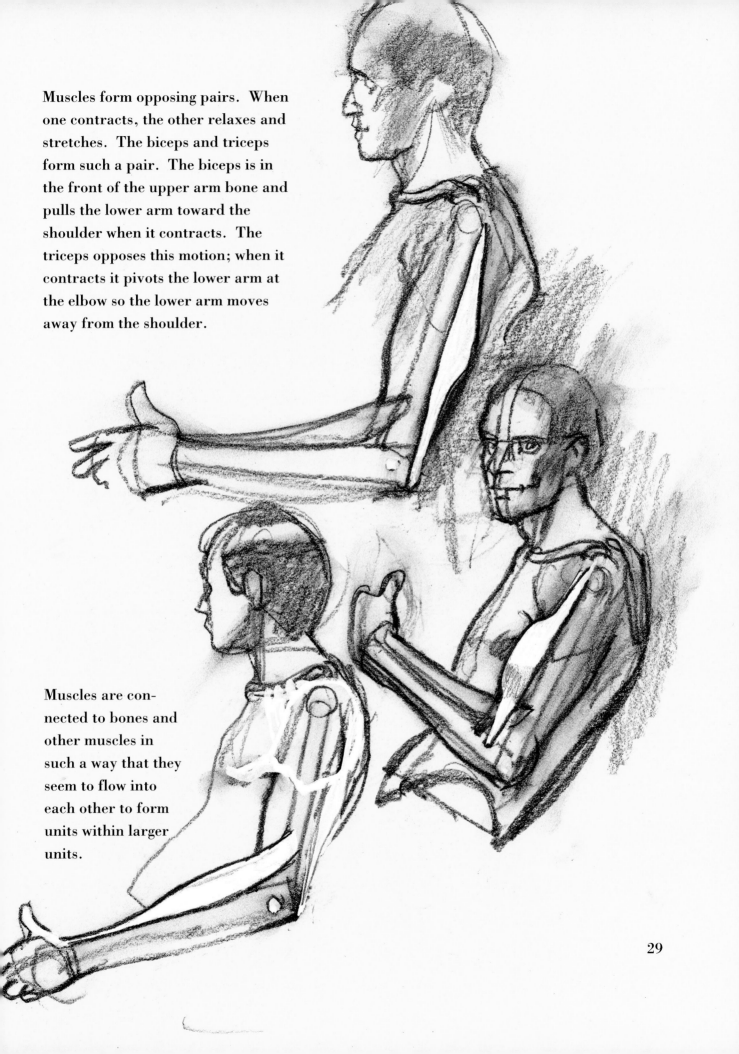

Muscles form opposing pairs. When one contracts, the other relaxes and stretches. The biceps and triceps form such a pair. The biceps is in the front of the upper arm bone and pulls the lower arm toward the shoulder when it contracts. The triceps opposes this motion; when it contracts it pivots the lower arm at the elbow so the lower arm moves away from the shoulder.

Muscles are connected to bones and other muscles in such a way that they seem to flow into each other to form units within larger units.

29

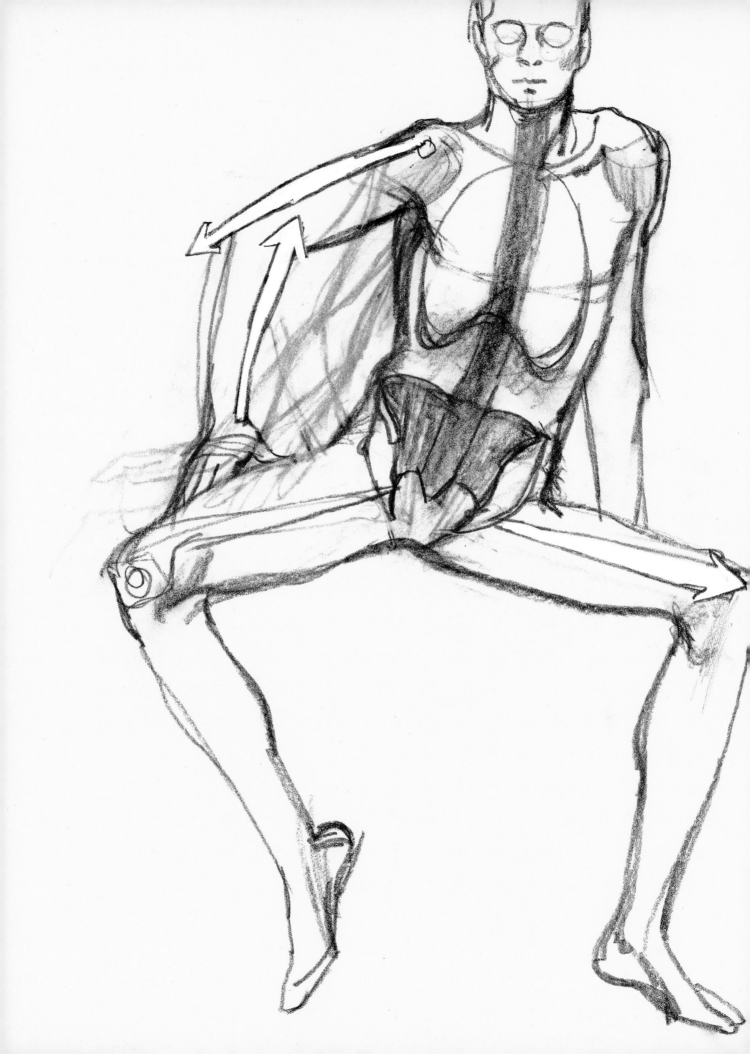

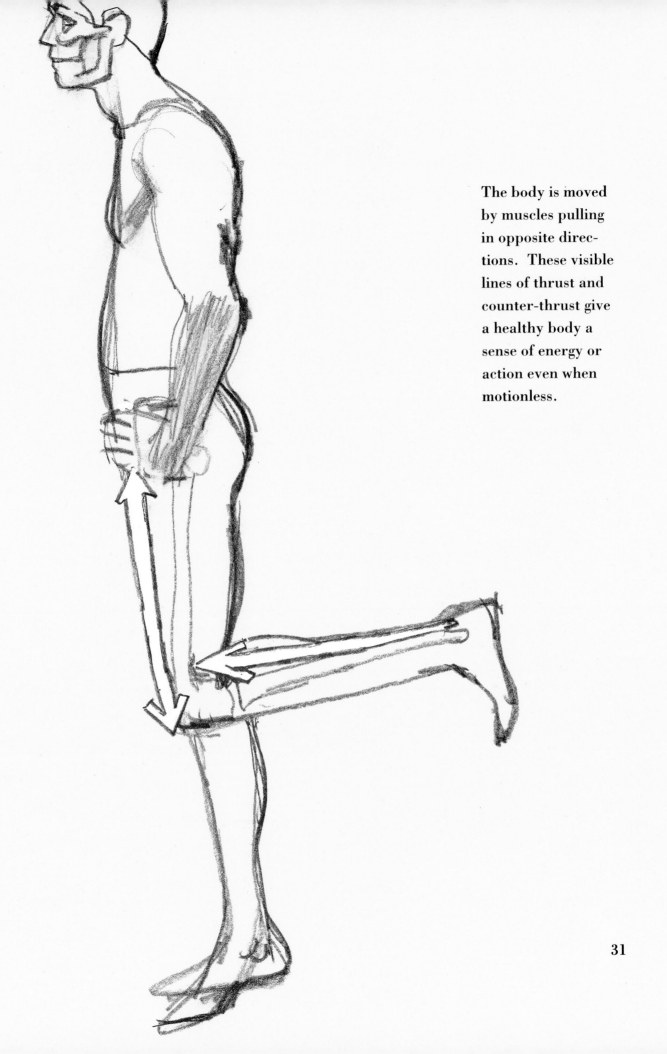

The body is moved
by muscles pulling
in opposite direc-
tions. These visible
lines of thrust and
counter-thrust give
a healthy body a
sense of energy or
action even when
motionless.

31

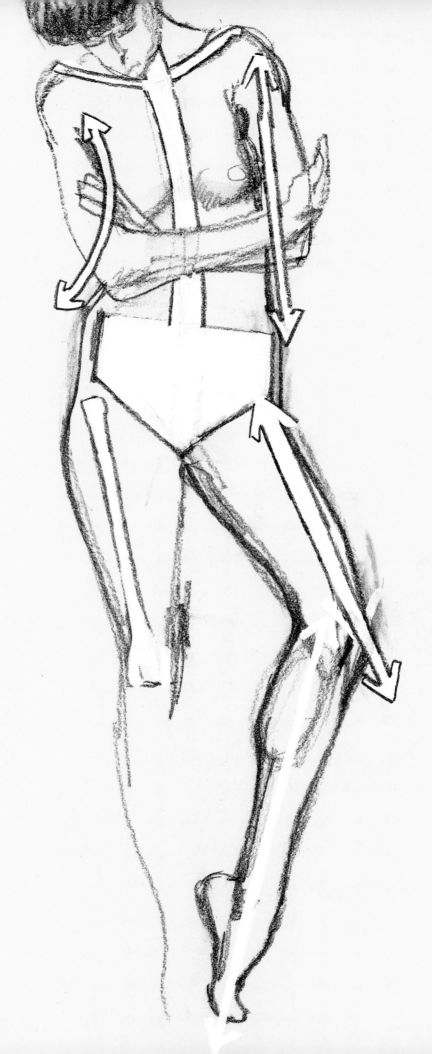

The systems of
muscles in various
states of tension
create dynamic lines
of force that produce
the distinctive ges-
ture of every pose.

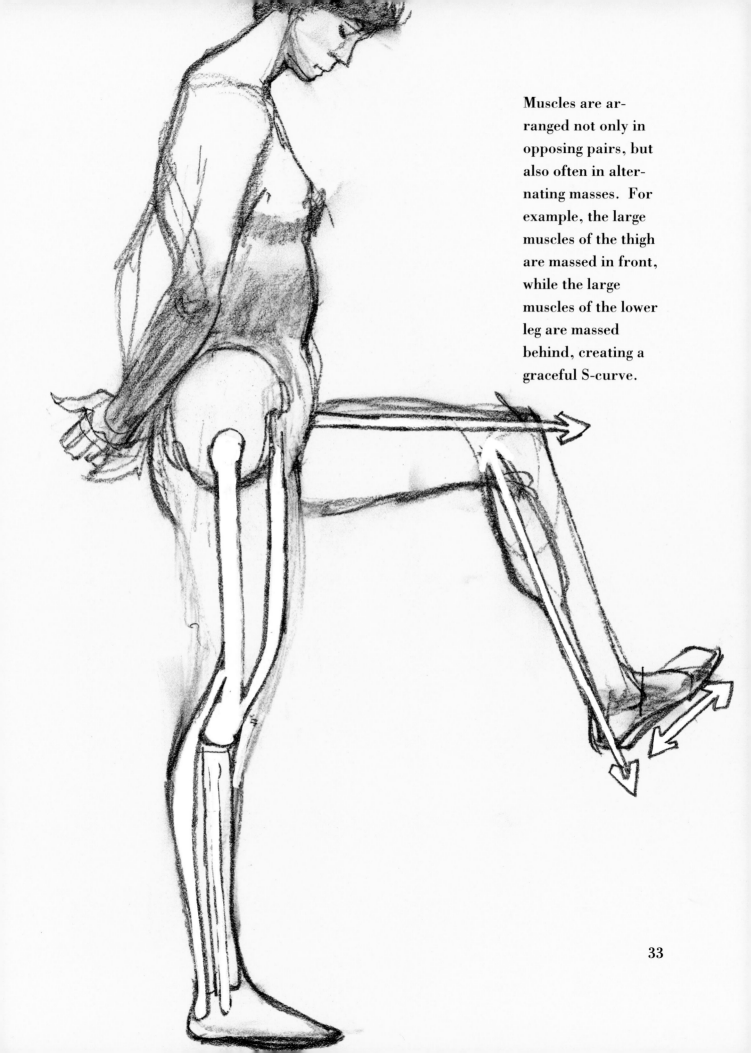

Muscles are arranged not only in opposing pairs, but also often in alternating masses. For example, the large muscles of the thigh are massed in front, while the large muscles of the lower leg are massed behind, creating a graceful S-curve.

33

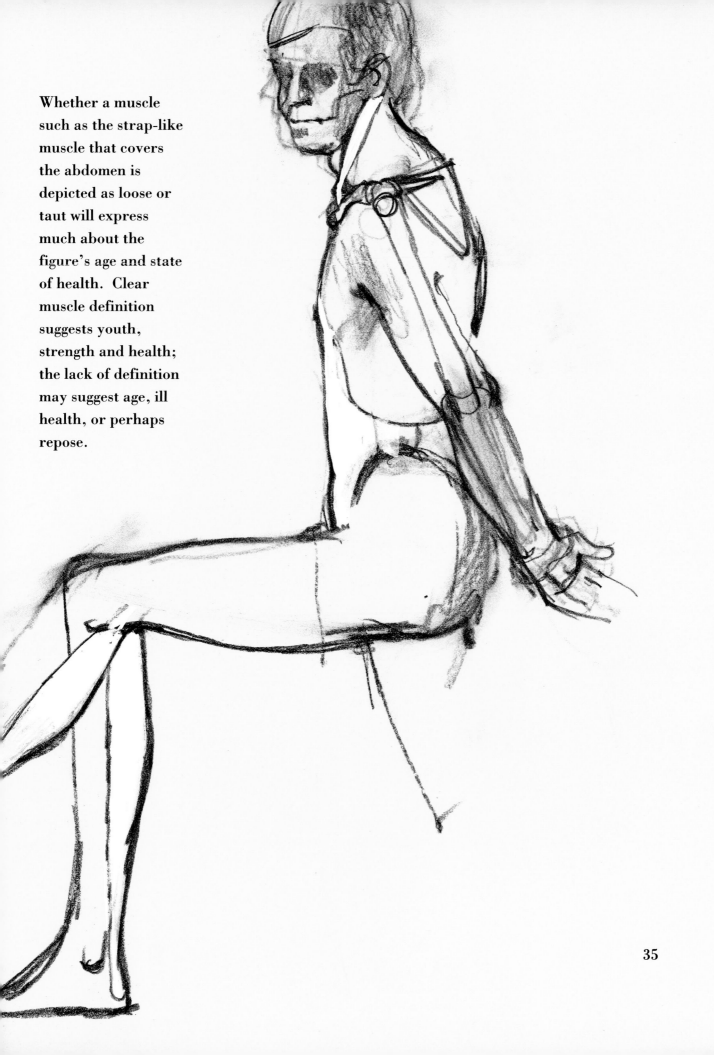

Whether a muscle such as the strap-like muscle that covers the abdomen is depicted as loose or taut will express much about the figure's age and state of health. Clear muscle definition suggests youth, strength and health; the lack of definition may suggest age, ill health, or perhaps repose.

35

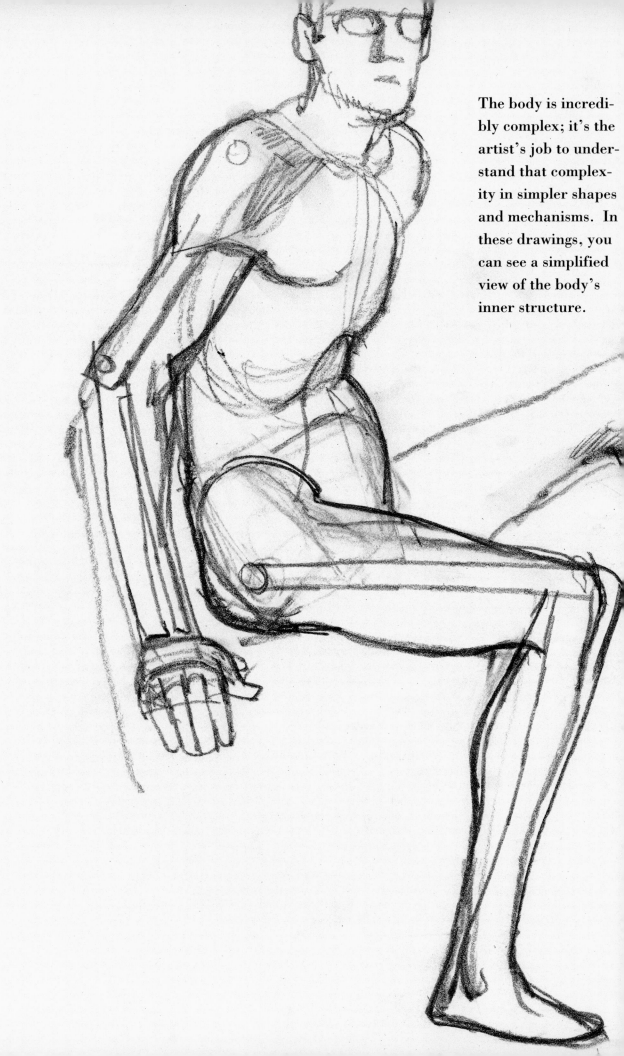

The body is incredibly complex; it's the artist's job to understand that complexity in simpler shapes and mechanisms. In these drawings, you can see a simplified view of the body's inner structure.

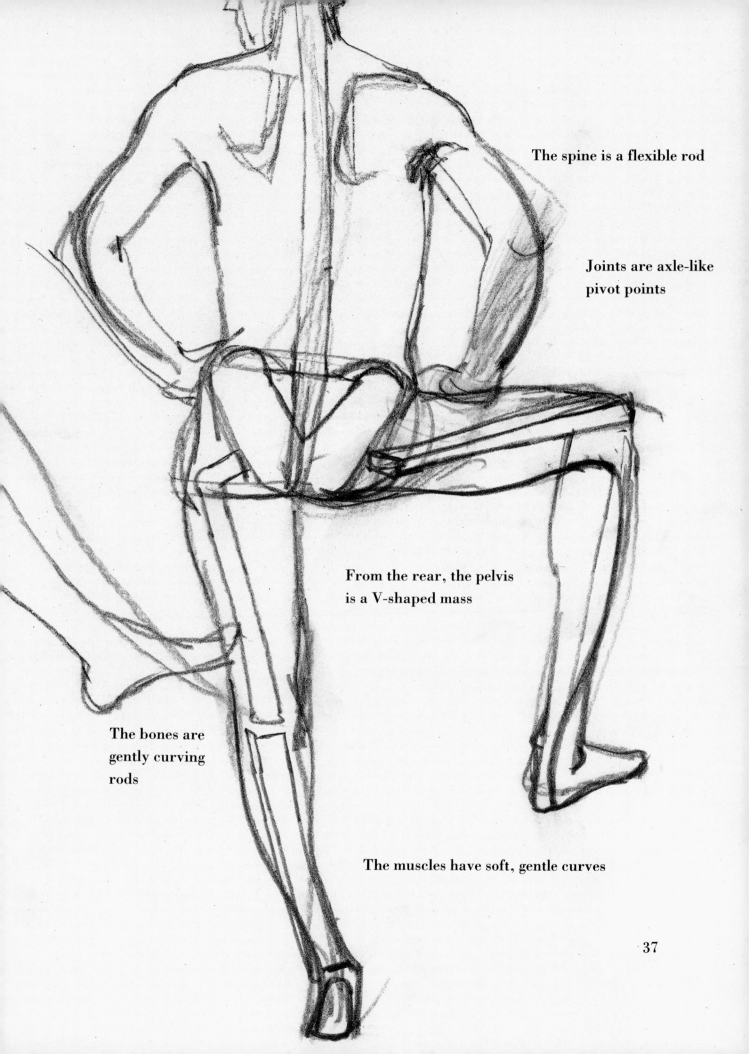

The spine is a flexible rod

Joints are axle-like
pivot points

From the rear, the pelvis
is a V-shaped mass

The bones are
gently curving
rods

The muscles have soft, gentle curves

37

CHAPTER 5

UNITS WITHIN UNITS

The head, rib cage, spine, and pelvis must be thought of as comprising a single unit within a larger unit, that is, the figure as a whole. Each figure drawing should depict these separate elements within the context of the whole because no part operates or can be understood in isolation. The skull, rib cage, and pelvis are to be visualized as a system of containers or armor protecting vital organs.

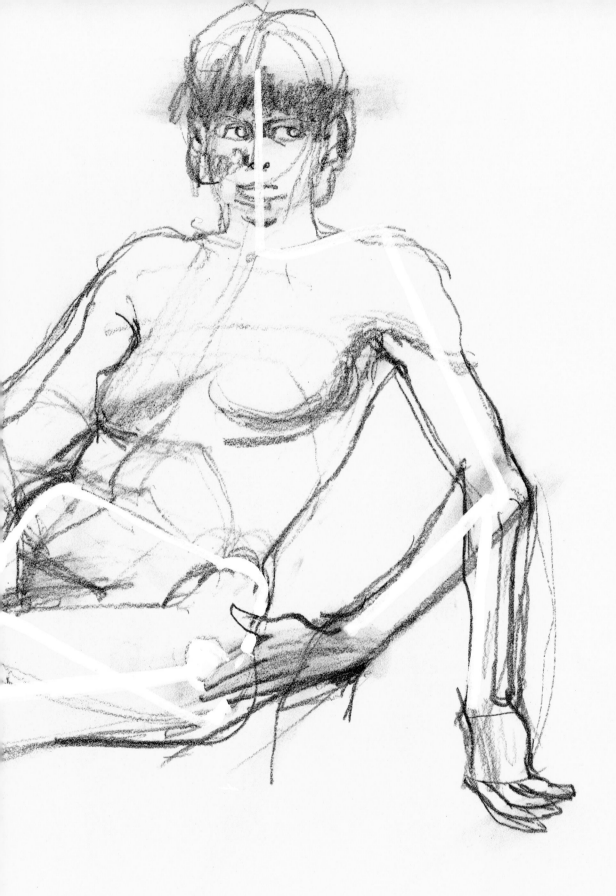

39

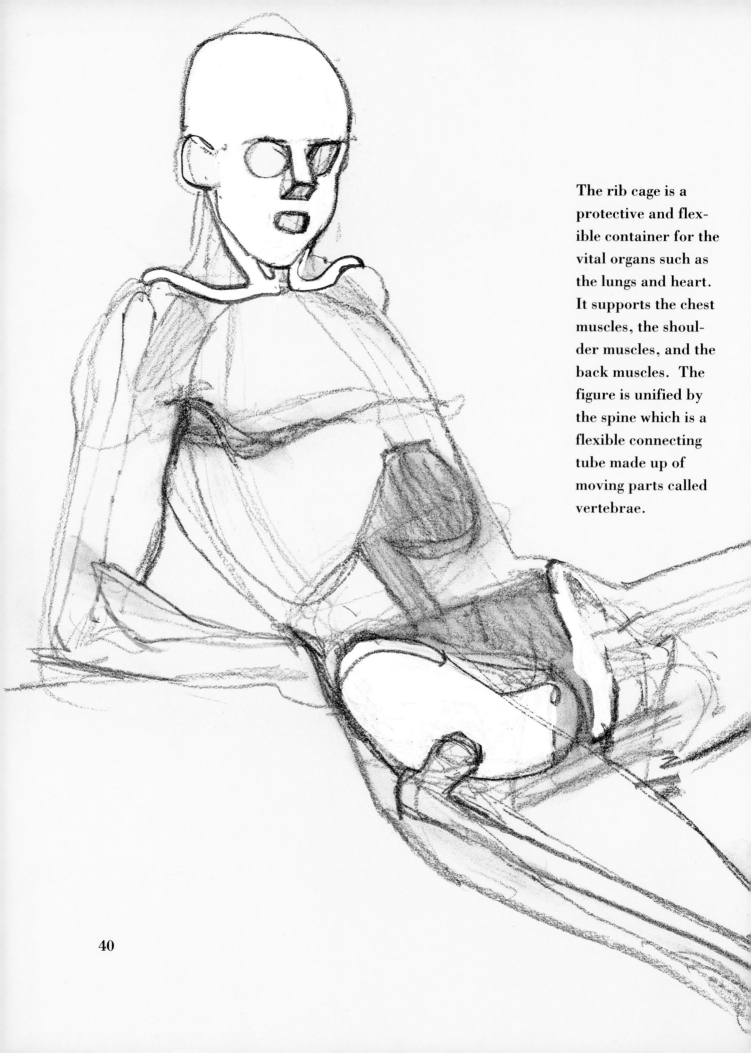

The rib cage is a
protective and flex-
ible container for the
vital organs such as
the lungs and heart.
It supports the chest
muscles, the shoul-
der muscles, and the
back muscles. The
figure is unified by
the spine which is a
flexible connecting
tube made up of
moving parts called
vertebrae.

40

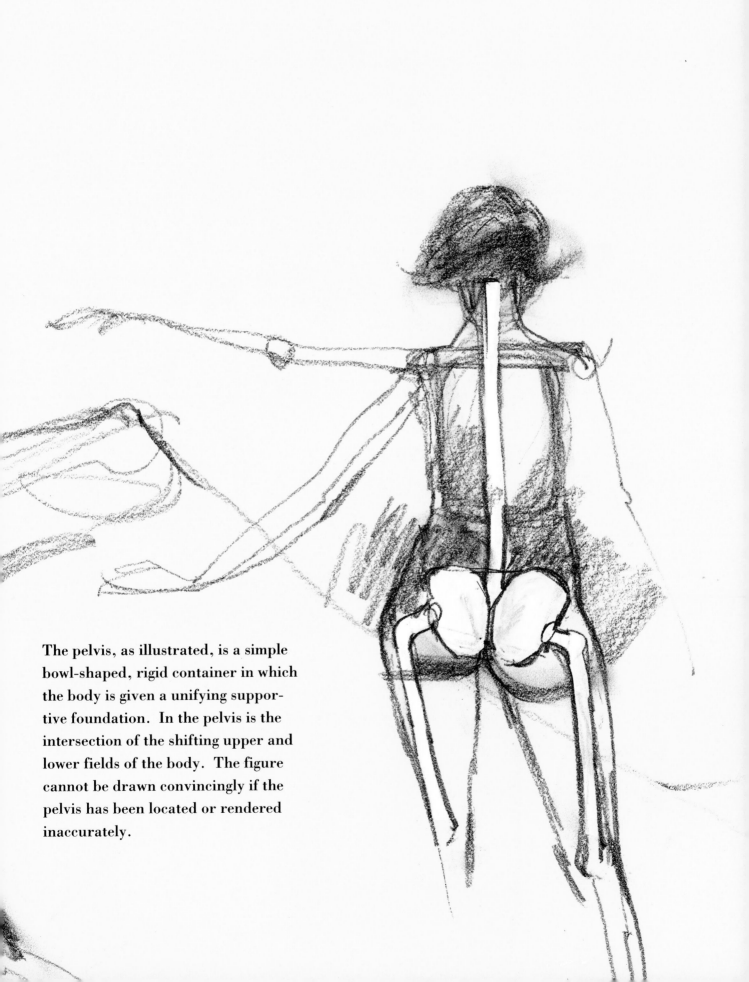

The pelvis, as illustrated, is a simple
bowl-shaped, rigid container in which
the body is given a unifying suppor-
tive foundation. In the pelvis is the
intersection of the shifting upper and
lower fields of the body. The figure
cannot be drawn convincingly if the
pelvis has been located or rendered
inaccurately.

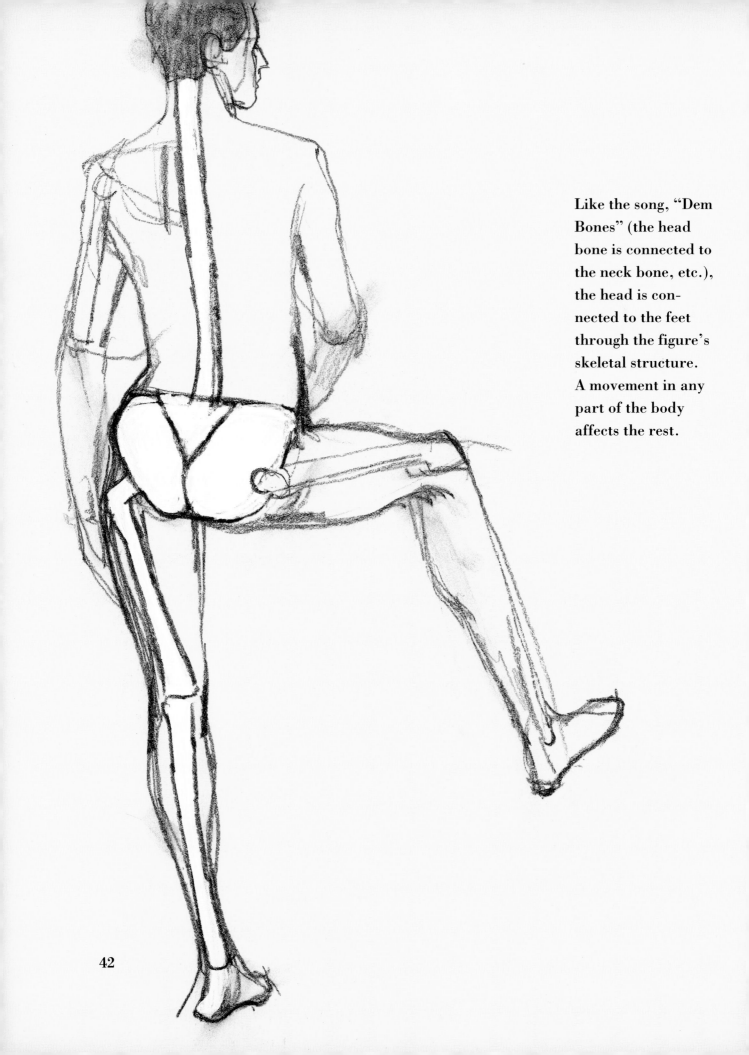

Like the song, "Dem Bones" (the head bone is connected to the neck bone, etc.), the head is connected to the feet through the figure's skeletal structure. A movement in any part of the body affects the rest.

42

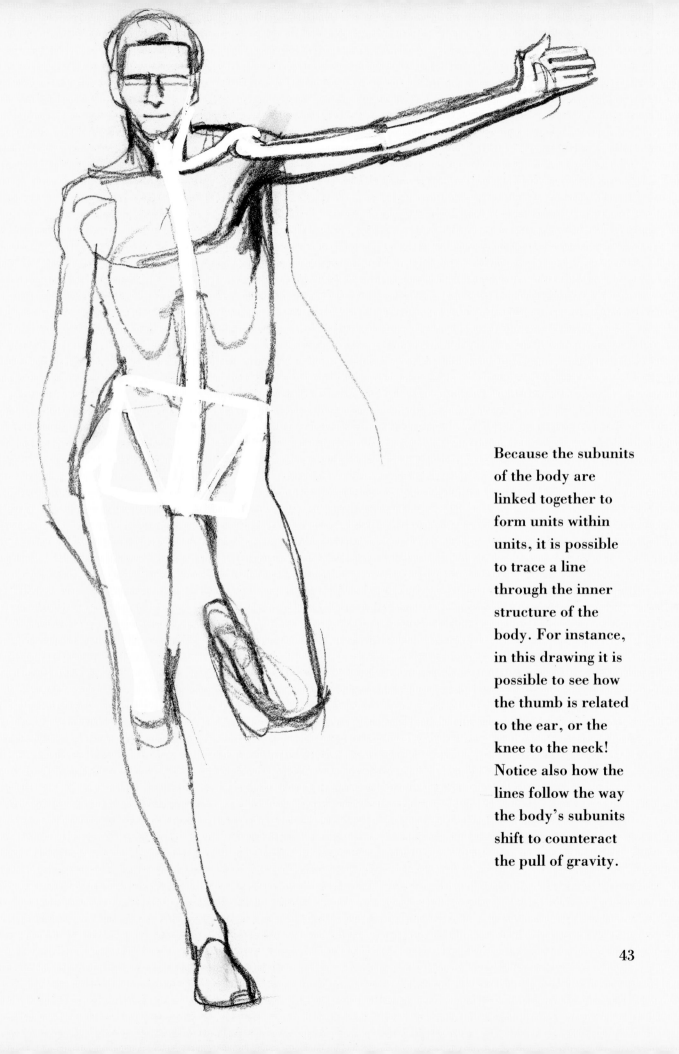

Because the subunits of the body are linked together to form units within units, it is possible to trace a line through the inner structure of the body. For instance, in this drawing it is possible to see how the thumb is related to the ear, or the knee to the neck! Notice also how the lines follow the way the body's subunits shift to counteract the pull of gravity.

43

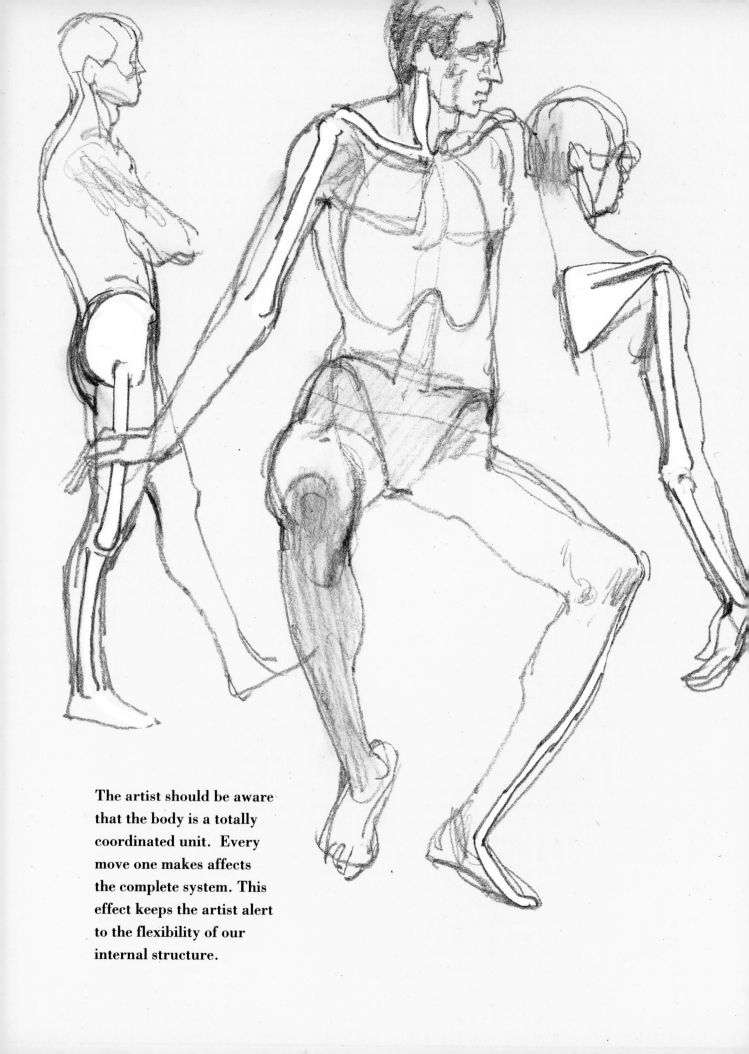

The artist should be aware
that the body is a totally
coordinated unit. Every
move one makes affects
the complete system. This
effect keeps the artist alert
to the flexibility of our
internal structure.

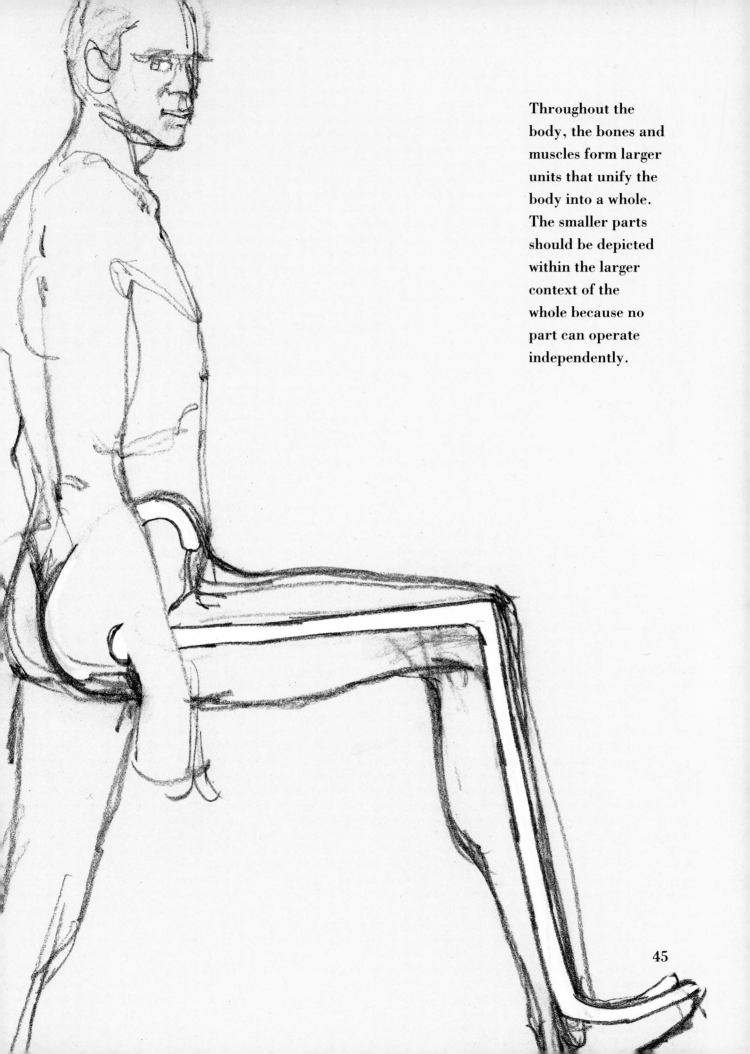

Throughout the body, the bones and muscles form larger units that unify the body into a whole. The smaller parts should be depicted within the larger context of the whole because no part can operate independently.

45

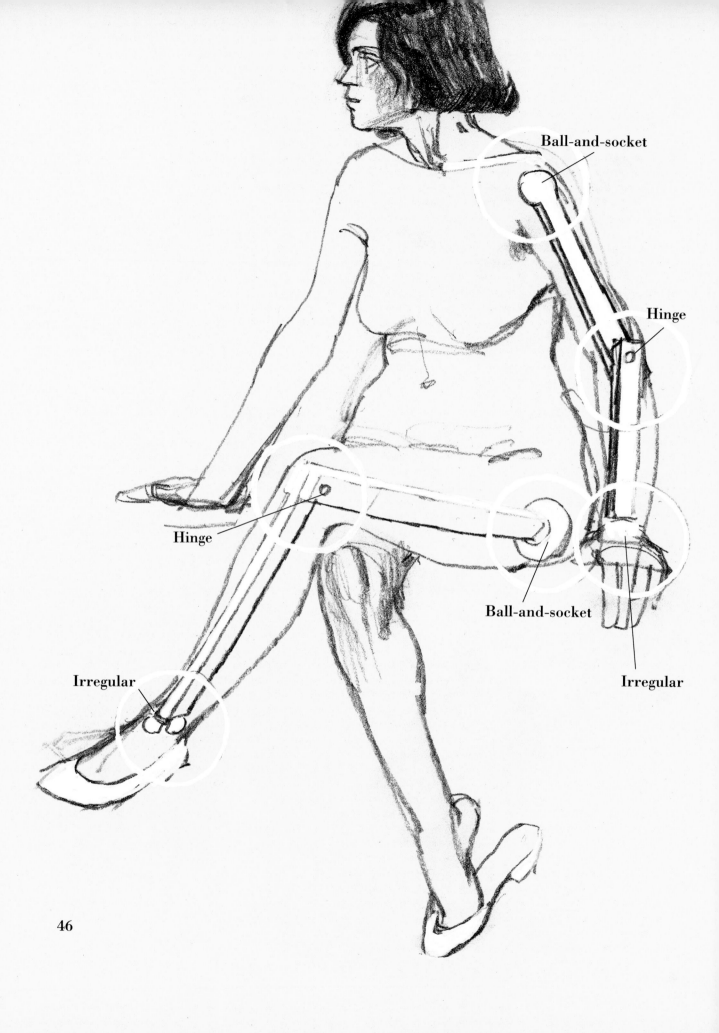

Ball-and-socket

Hinge

Hinge

Ball-and-socket

Irregular

Irregular

46

CHAPTER 6

JOINTS

There are, for the artist's purposes, three categories of skeletal joints: ball-and-socket, hinge, and irregular.

The ball-and-socket joints permit roughly ninety-five percent freedom of action. They provide adjacent limbs the ability to extend in a nearly complete 360-degree circle. The disadvantage of this range of motion is that these joints would be relatively unstable if they weren't surrounded by the largest muscles in the body.

The collarbone and the shoulder blade meet to form a cup-shape socket at the top of the shoulder. Into this inserts the rounded end of the upper arm bone, completing a ball-and-socket joint. Covering it and keeping it in place is the deltoid muscle. In a similar manner, the rounded end of the upper leg bone inserts into the cup-shaped socket of the pelvis. It is supported in this position by the buttocks and a variety of lesser muscles.

The hinge joints such as the knee or elbow bend only in one direction and are less flexible but more rigid and stronger than the ball-and-socket joints. They lock into a rigid position and provide exceptional leverage. The arm is a lever with its power (insertion of biceps) located between the fulcrum (the elbow) and the point of resistance (the hand). This provides us with an exceptional ability to pull objects in one direc-tion—towards the body. The elbows allow movement only in two directions. They are highly specialized for activities such as pulling roots out of the ground and tearing fruit from branches. The legs, which also possess this highly specific ability to lock into position because of their hinge-type knee joint, guarantee balance and support as the body moves about. The need for stable joints explains why these limbs are hinged in this way at these locations.

Irregular joints are found in the wrist and ankle, where a number of small bones are located, allowing for the rather complex movements of the hand and foot.

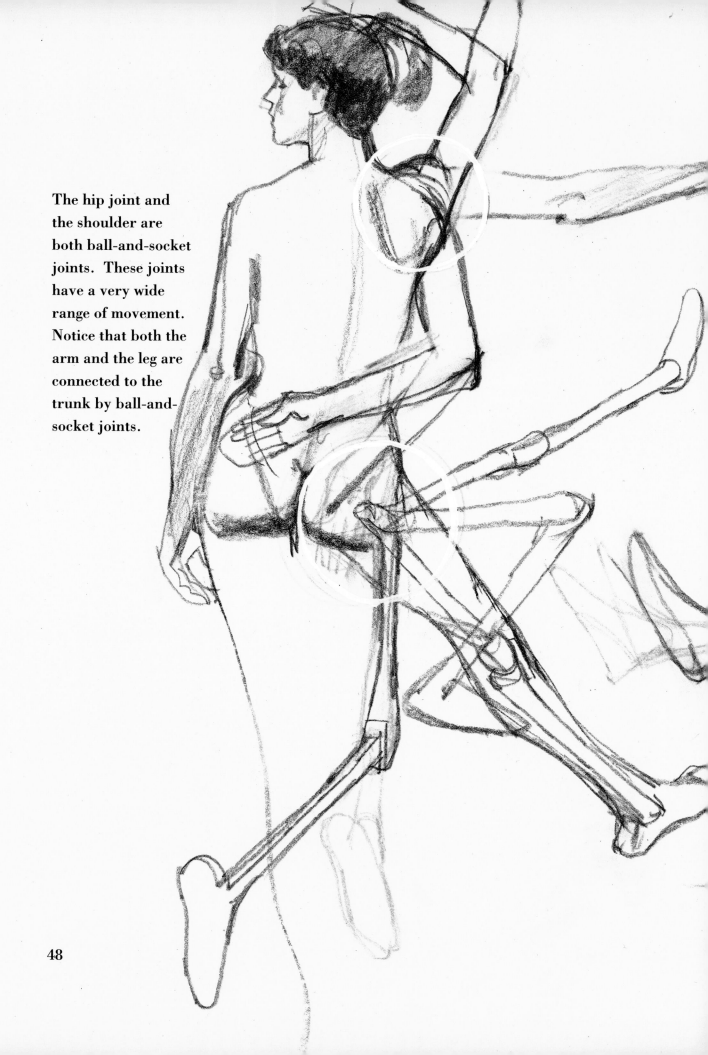

The hip joint and
the shoulder are
both ball-and-socket
joints. These joints
have a very wide
range of movement.
Notice that both the
arm and the leg are
connected to the
trunk by ball-and-
socket joints.

48

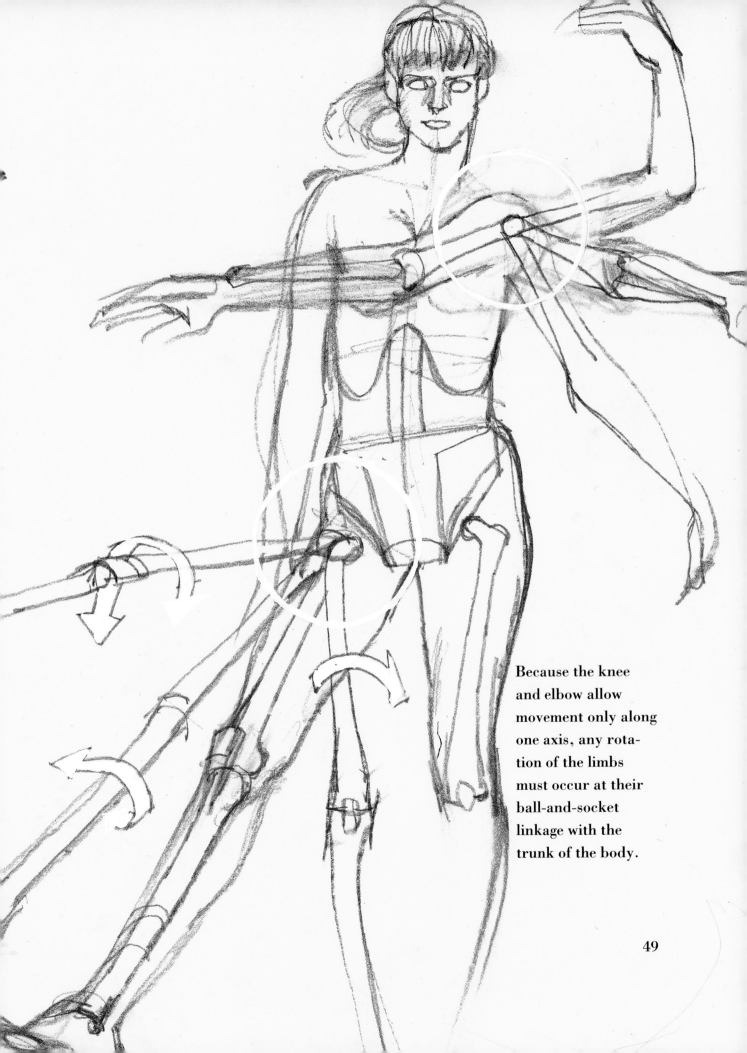

Because the knee
and elbow allow
movement only along
one axis, any rota-
tion of the limbs
must occur at their
ball-and-socket
linkage with the
trunk of the body.

49

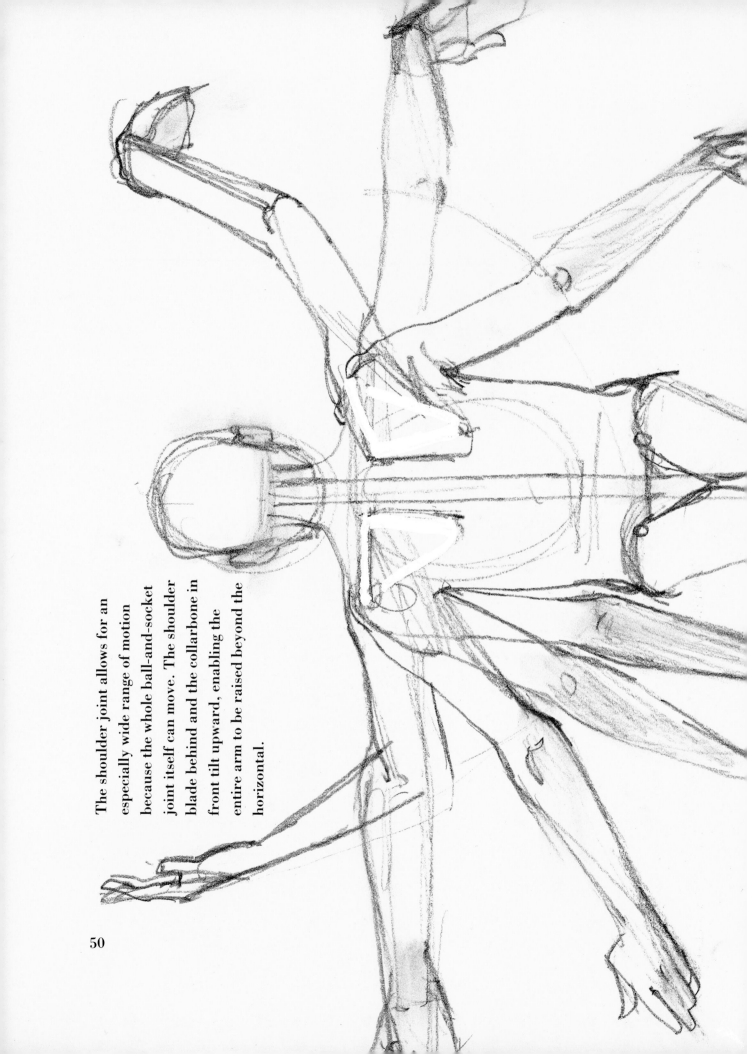

The shoulder joint allows for an especially wide range of motion because the whole ball-and-socket joint itself can move. The shoulder blade behind and the collarbone in front tilt upward, enabling the entire arm to be raised beyond the horizontal.

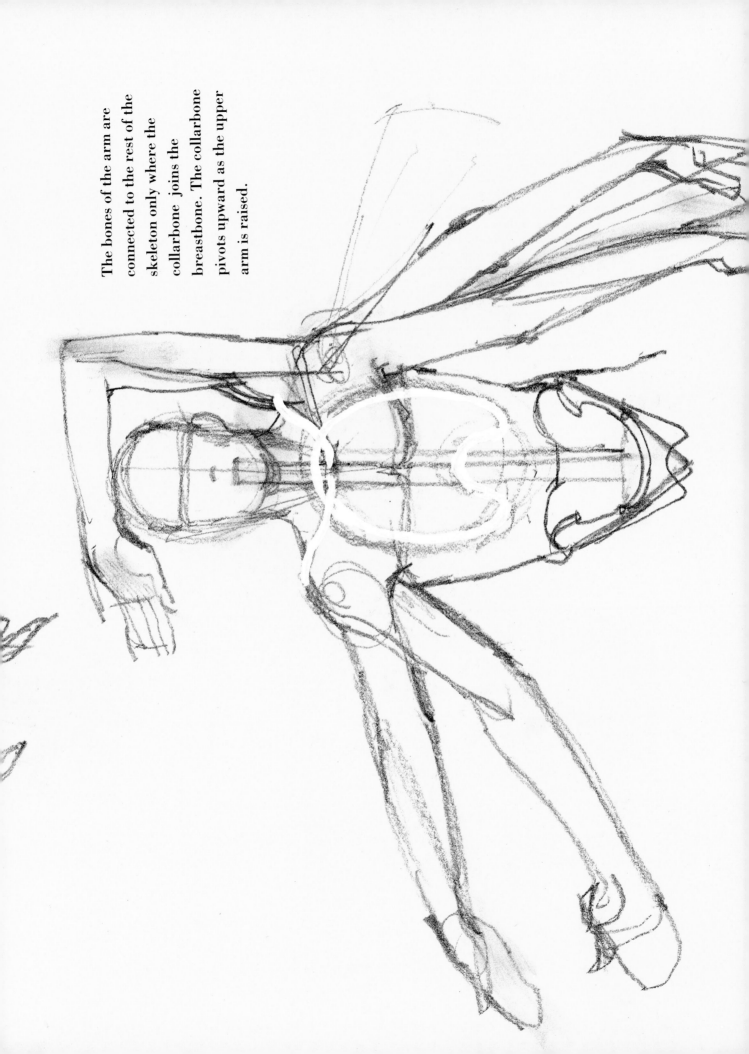

The bones of the arm are connected to the rest of the skeleton only where the collarbone joins the breastbone. The collarbone pivots upward as the upper arm is raised.

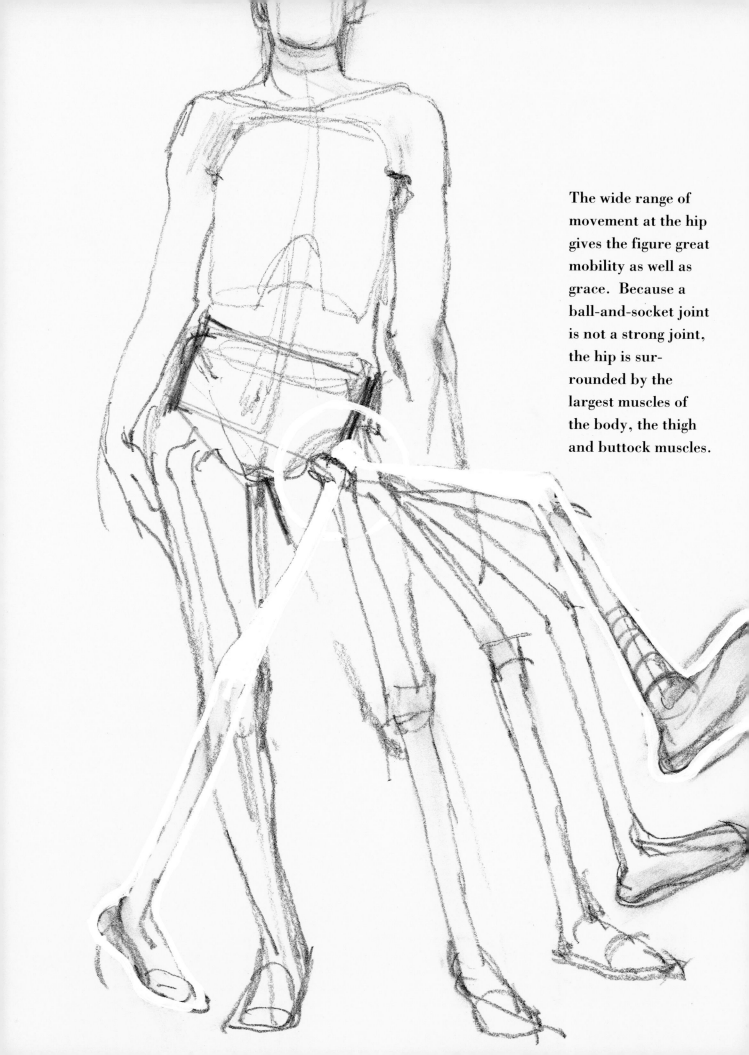

The wide range of
movement at the hip
gives the figure great
mobility as well as
grace. Because a
ball-and-socket joint
is not a strong joint,
the hip is sur-
rounded by the
largest muscles of
the body, the thigh
and buttock muscles.

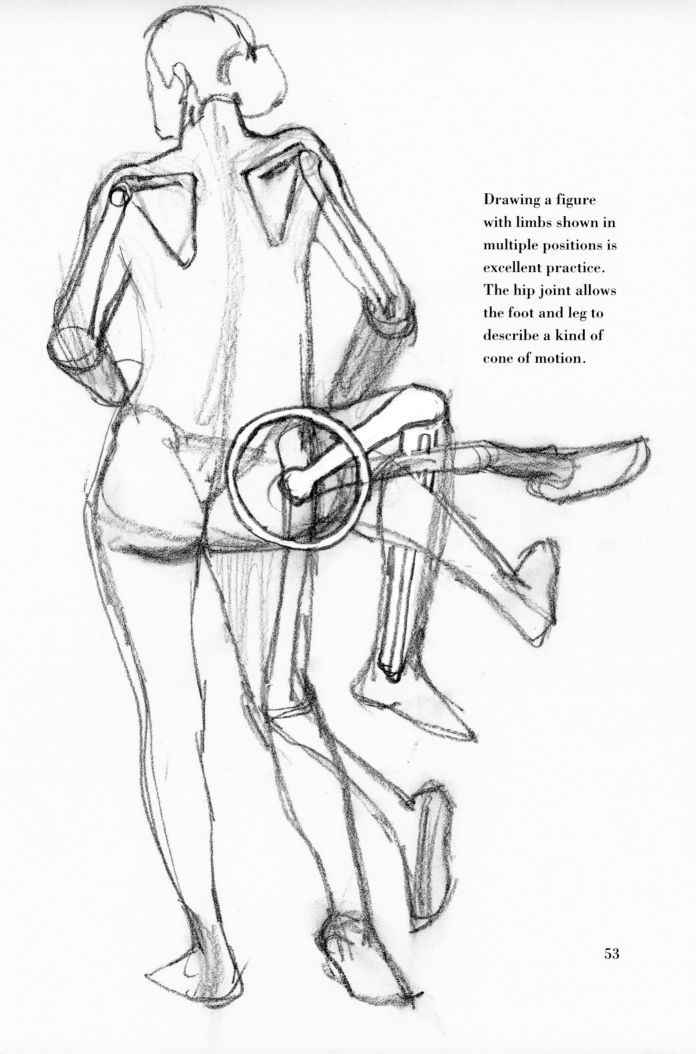

Drawing a figure
with limbs shown in
multiple positions is
excellent practice.
The hip joint allows
the foot and leg to
describe a kind of
cone of motion.

53

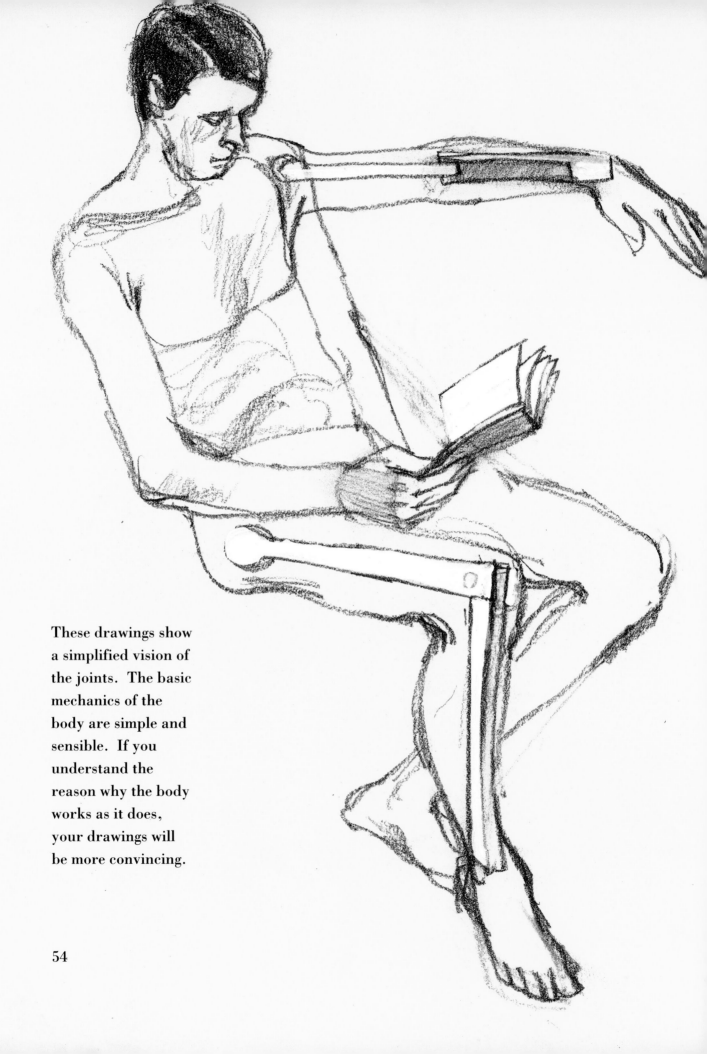

These drawings show
a simplified vision of
the joints. The basic
mechanics of the
body are simple and
sensible. If you
understand the
reason why the body
works as it does,
your drawings will
be more convincing.

54

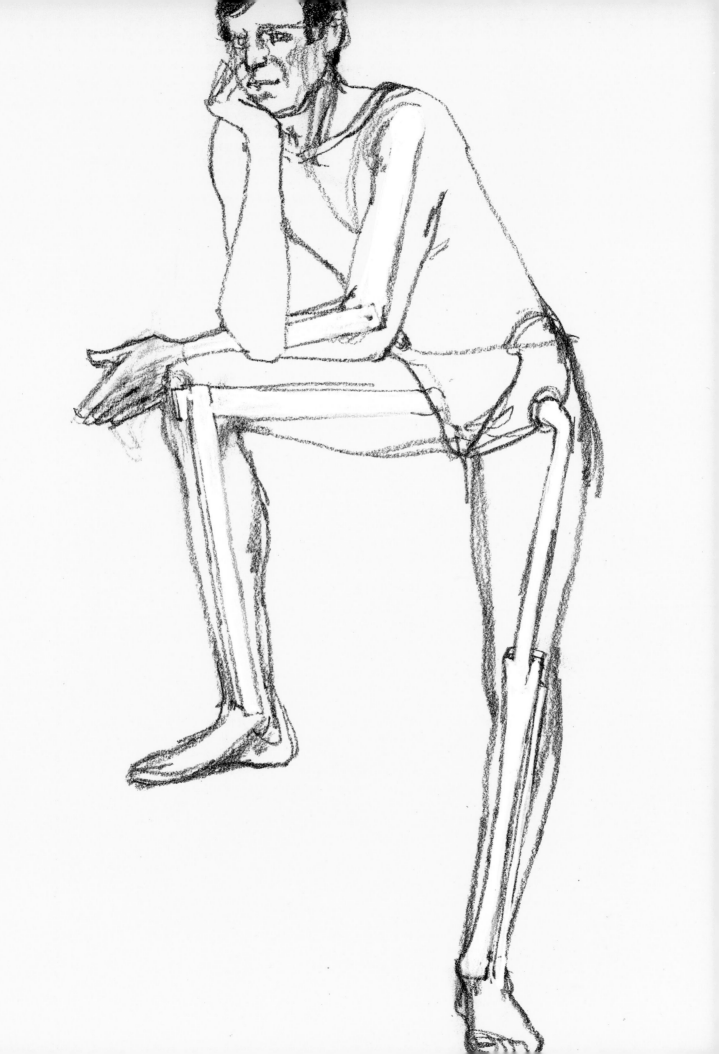

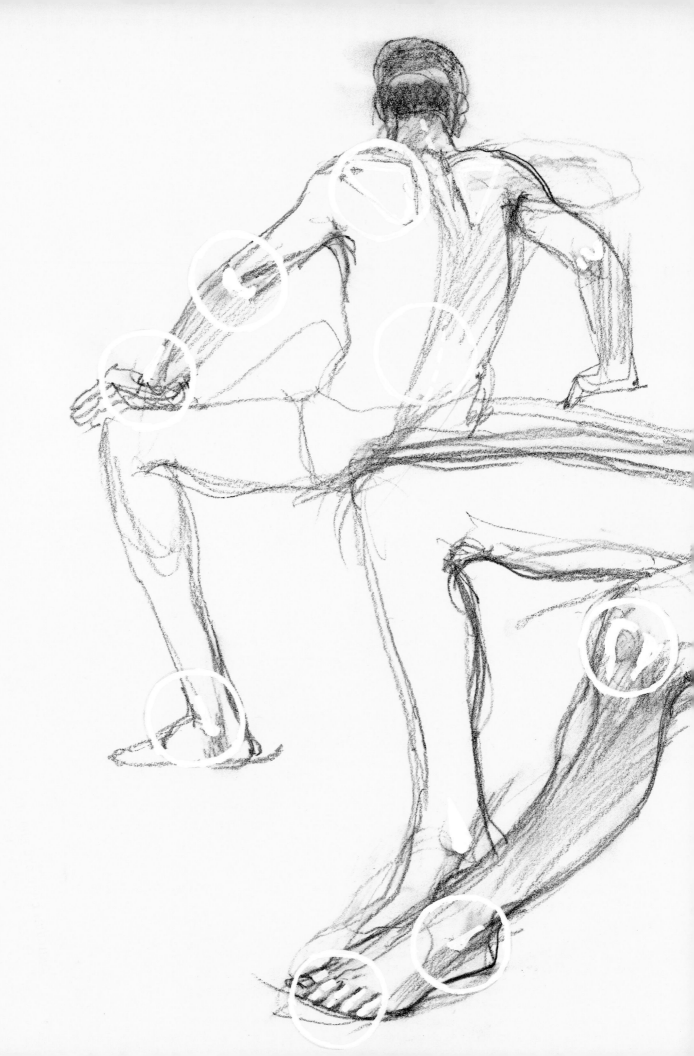

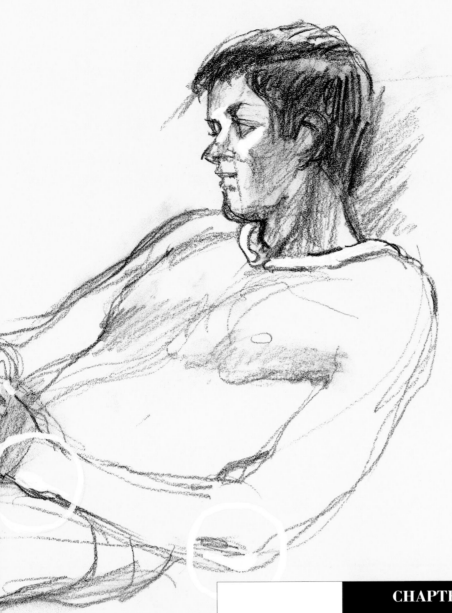

VISIBLE BONES

There are approximately thirty-one points where the bones are visible under the skin. Examples are the elbows, ankles, wrists, knees, pelvis, collarbones, shoulder blades, knuckles, upper tip of the spine, bridge of the nose, and cheekbones. An artist must be aware of and capable of correctly indicating these points to give a feeling of the boniness of the human form. No matter the degree of fleshiness of a particular human figure, these points are almost always visible. This is particularly true at the joints.

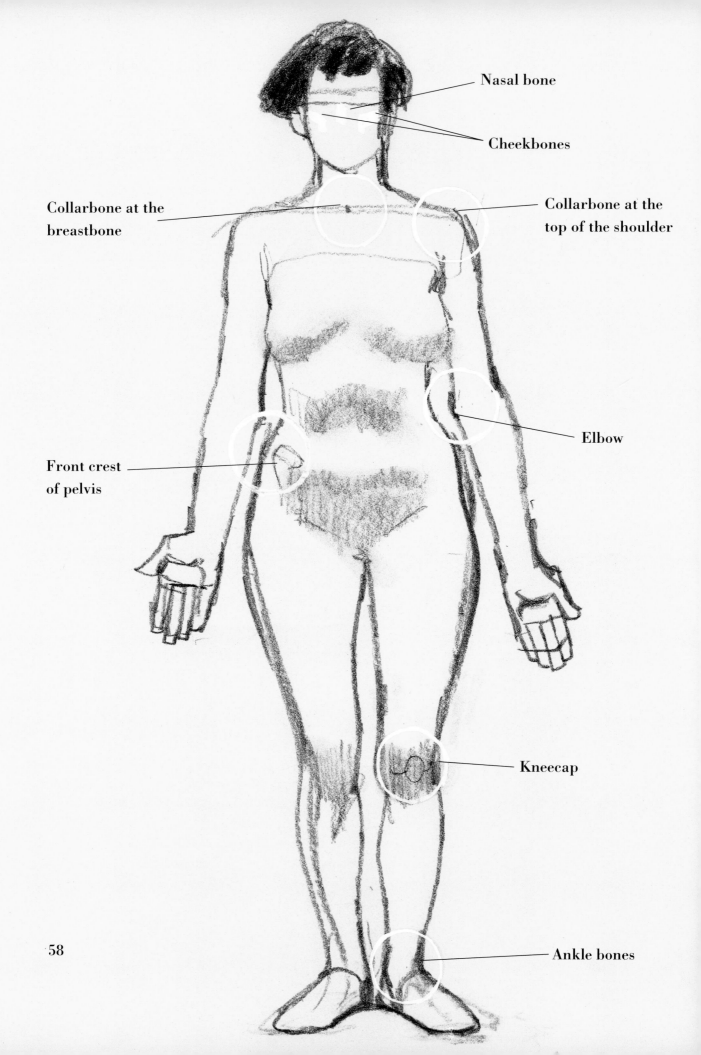

Nasal bone

Cheekbones

Collarbone at the
breastbone

Collarbone at the
top of the shoulder

Elbow

Front crest
of pelvis

Kneecap

58

Ankle bones

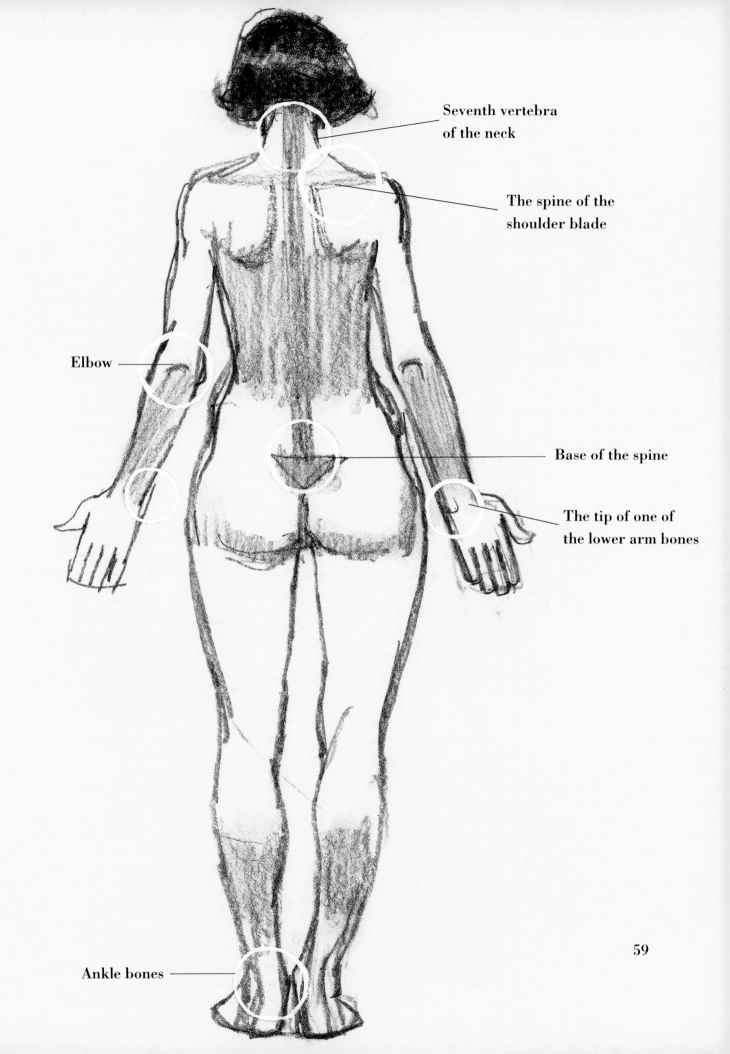

Seventh vertebra
of the neck

The spine of the
shoulder blade

Elbow

Base of the spine

The tip of one of
the lower arm bones

Ankle bones

59

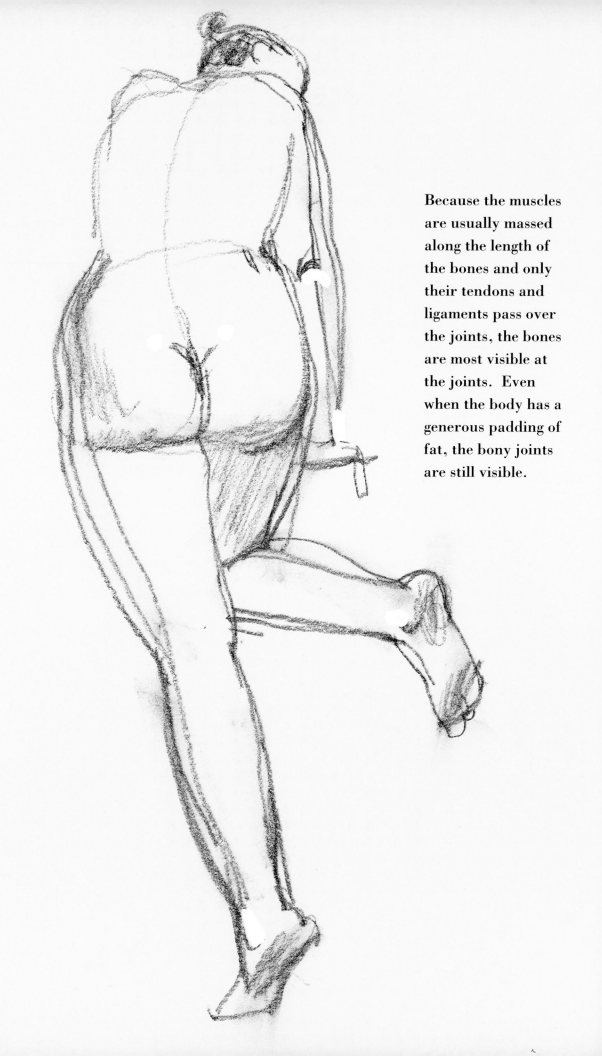

Because the muscles
are usually massed
along the length of
the bones and only
their tendons and
ligaments pass over
the joints, the bones
are most visible at
the joints. Even
when the body has a
generous padding of
fat, the bony joints
are still visible.

60

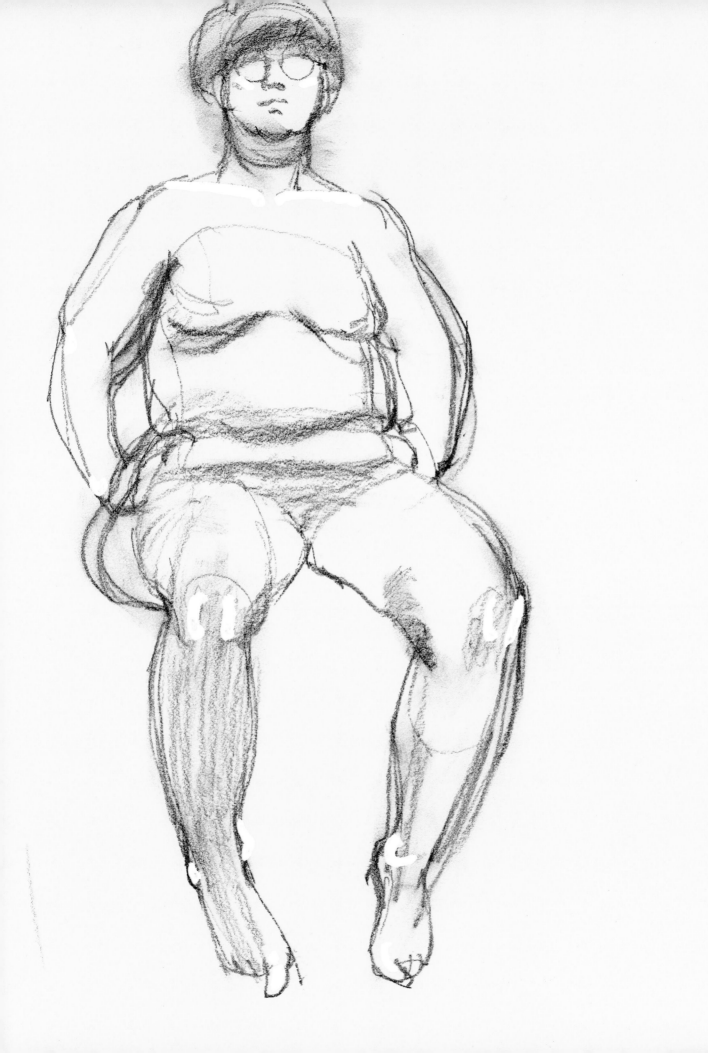

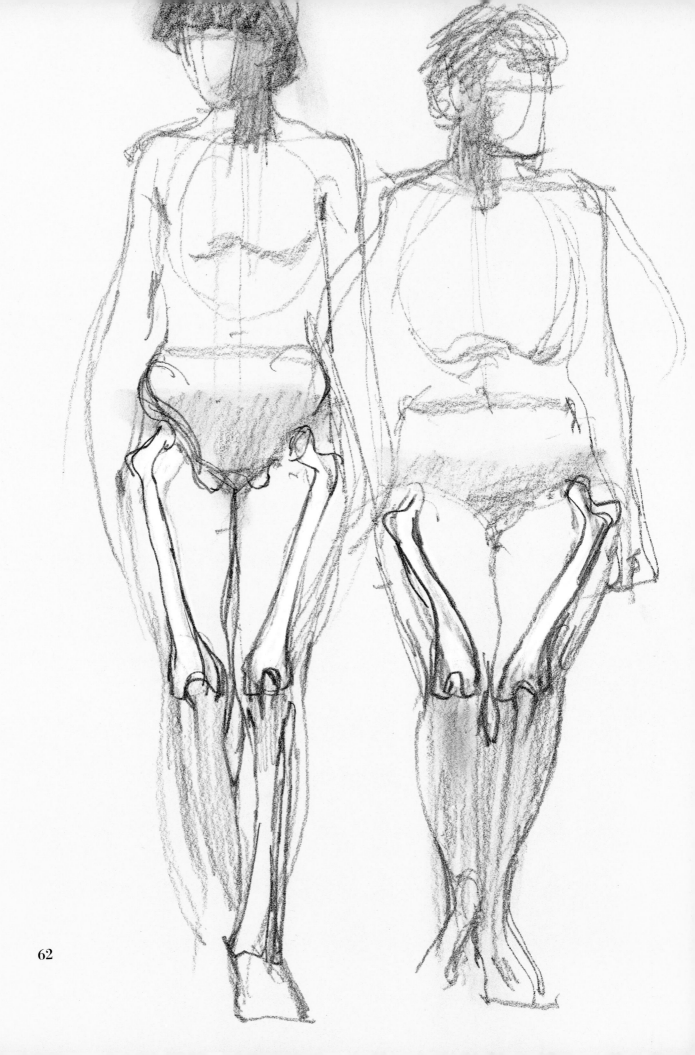

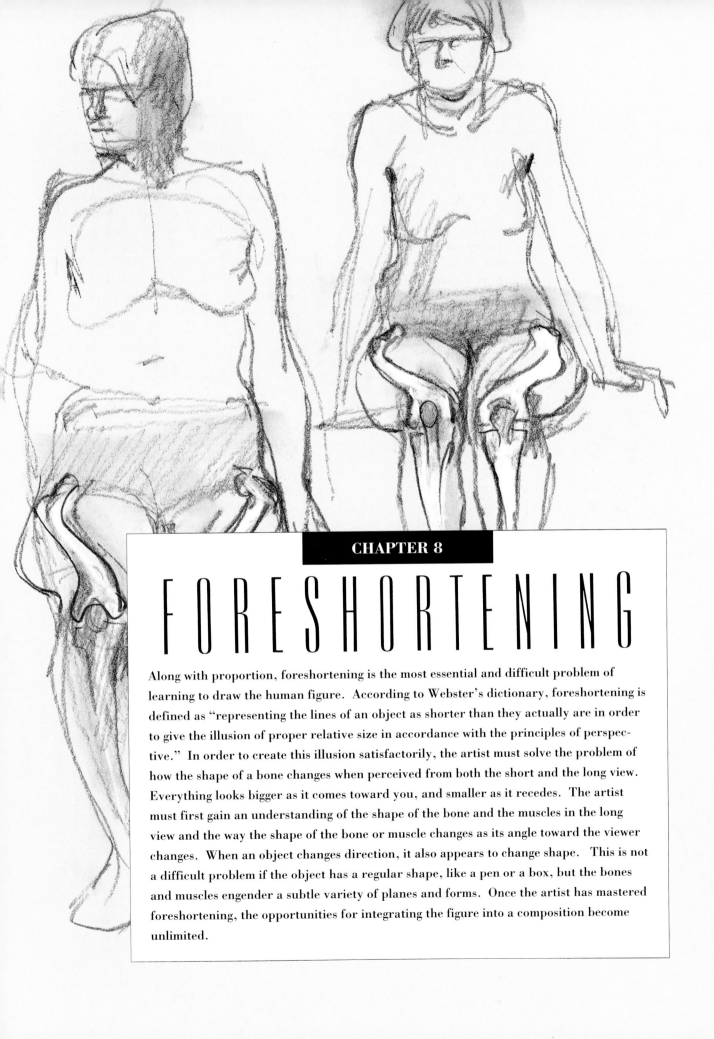

FORESHORTENING

Along with proportion, foreshortening is the most essential and difficult problem of learning to draw the human figure. According to Webster's dictionary, foreshortening is defined as "representing the lines of an object as shorter than they actually are in order to give the illusion of proper relative size in accordance with the principles of perspective." In order to create this illusion satisfactorily, the artist must solve the problem of how the shape of a bone changes when perceived from both the short and the long view. Everything looks bigger as it comes toward you, and smaller as it recedes. The artist must first gain an understanding of the shape of the bone and the muscles in the long view and the way the shape of the bone or muscle changes as its angle toward the viewer changes. When an object changes direction, it also appears to change shape. This is not a difficult problem if the object has a regular shape, like a pen or a box, but the bones and muscles engender a subtle variety of planes and forms. Once the artist has mastered foreshortening, the opportunities for integrating the figure into a composition become unlimited.

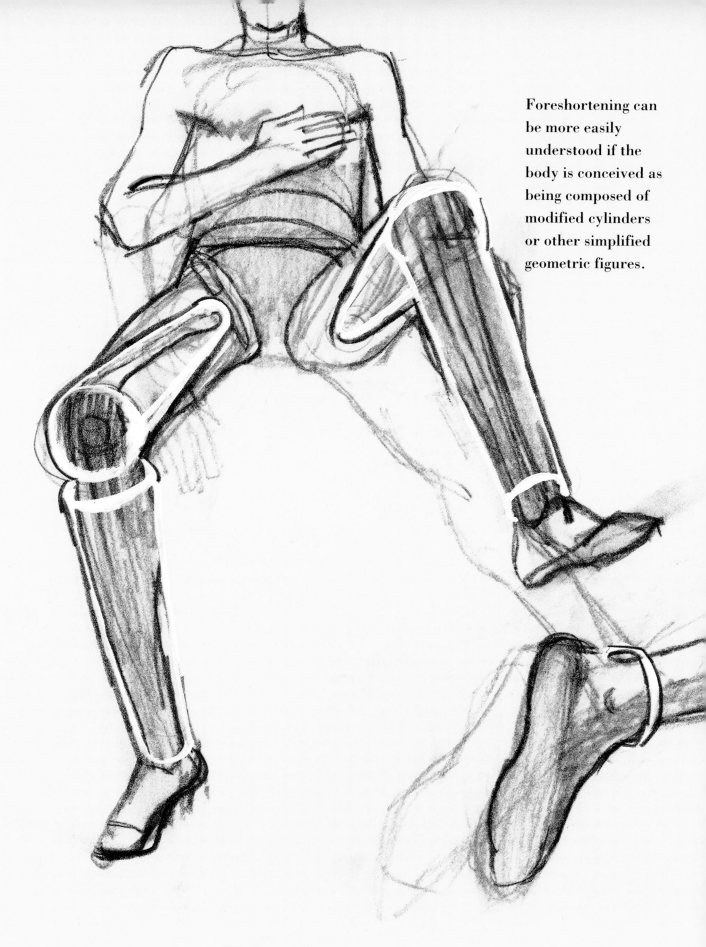

Foreshortening can be more easily understood if the body is conceived as being composed of modified cylinders or other simplified geometric figures.

64

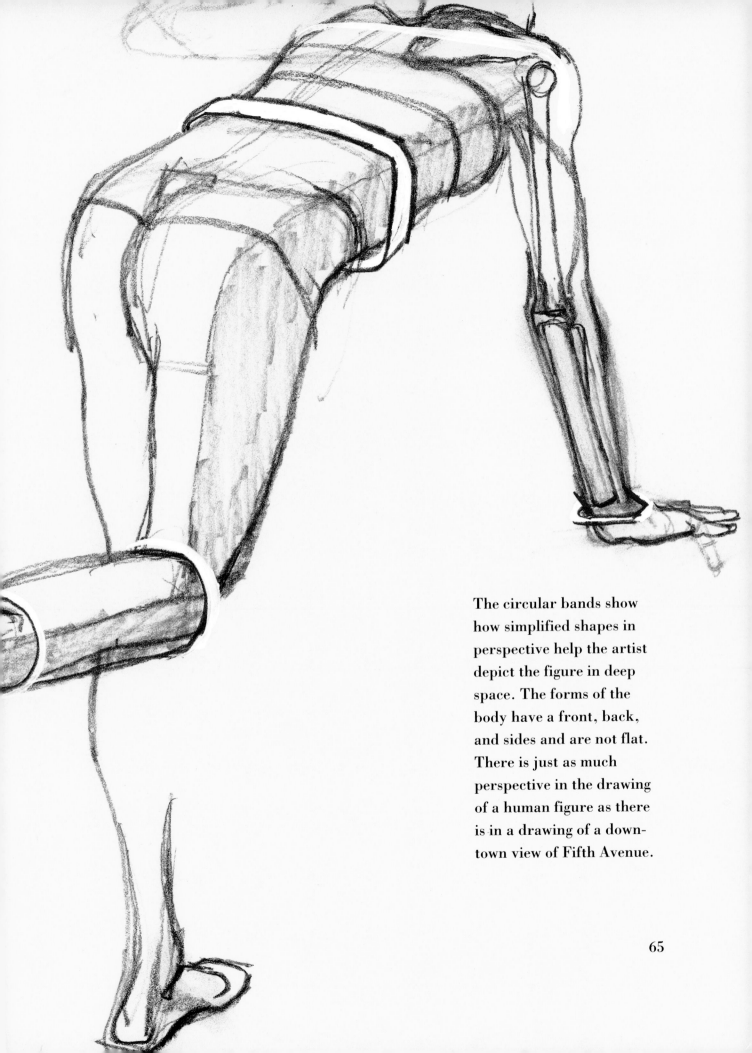

The circular bands show
how simplified shapes in
perspective help the artist
depict the figure in deep
space. The forms of the
body have a front, back,
and sides and are not flat.
There is just as much
perspective in the drawing
of a human figure as there
is in a drawing of a down-
town view of Fifth Avenue.

65

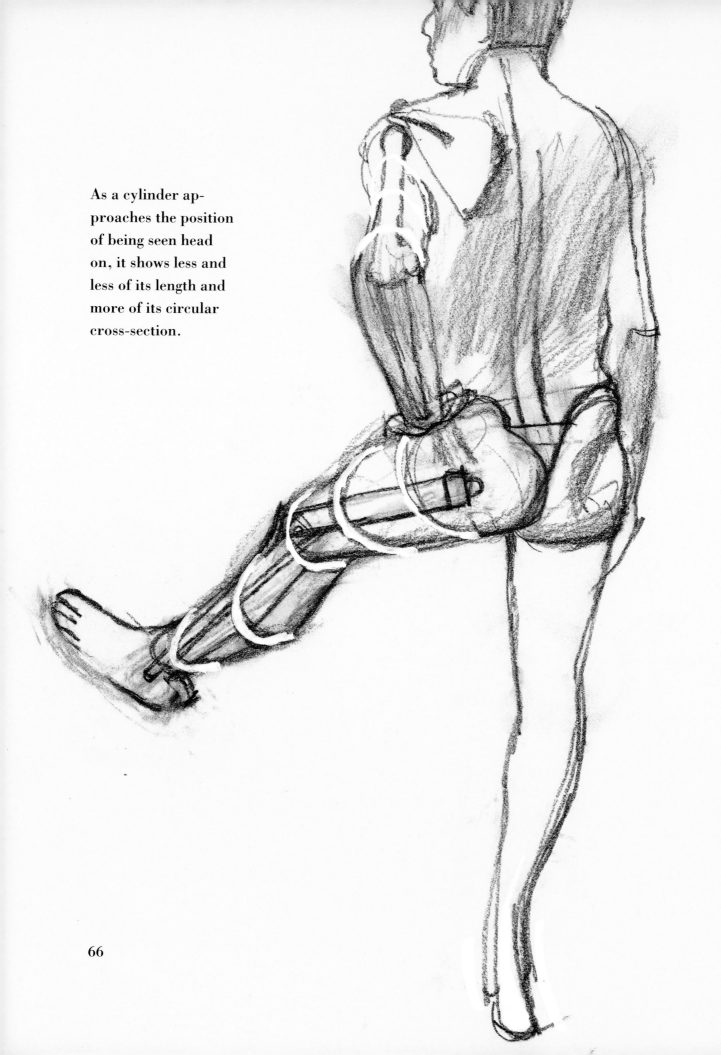

As a cylinder approaches the position of being seen head on, it shows less and less of its length and more of its circular cross-section.

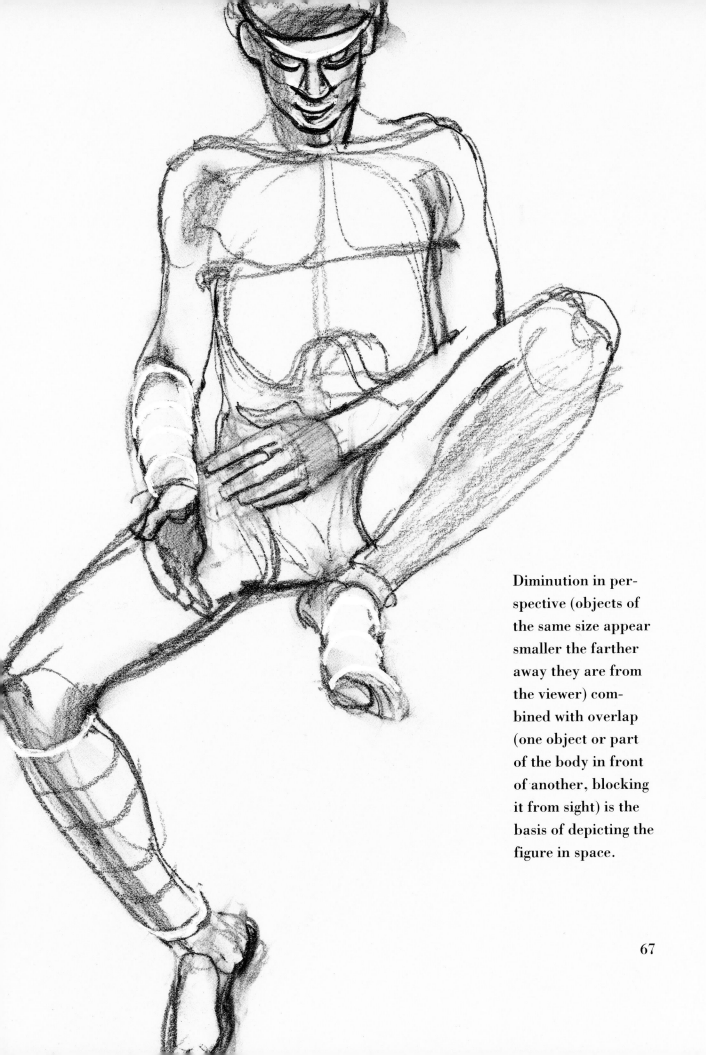

Diminution in perspective (objects of the same size appear smaller the farther away they are from the viewer) combined with overlap (one object or part of the body in front of another, blocking it from sight) is the basis of depicting the figure in space.

67

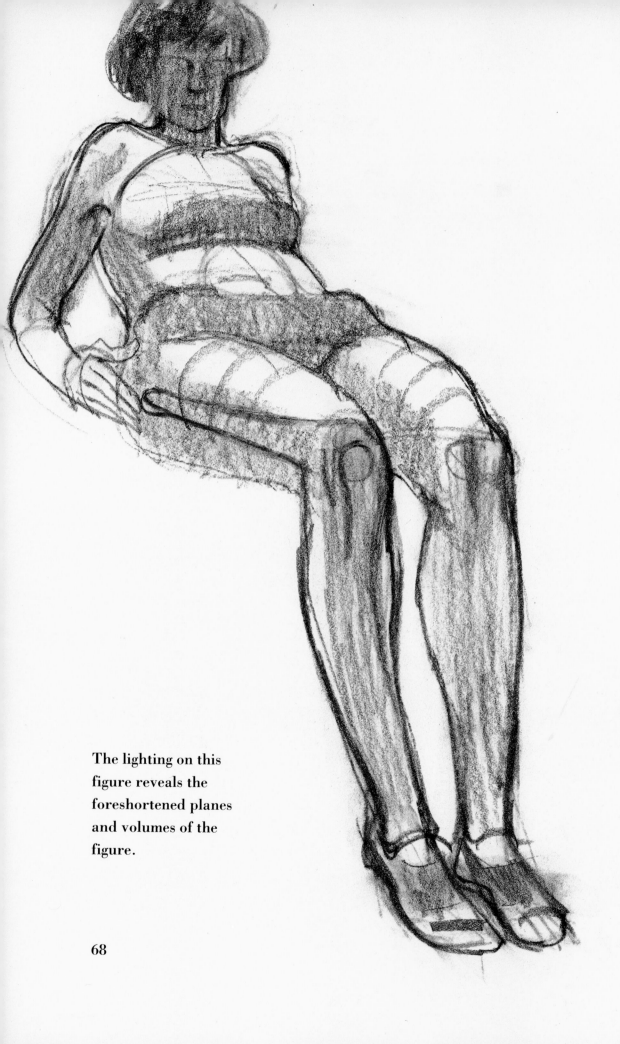

The lighting on this
figure reveals the
foreshortened planes
and volumes of the
figure.

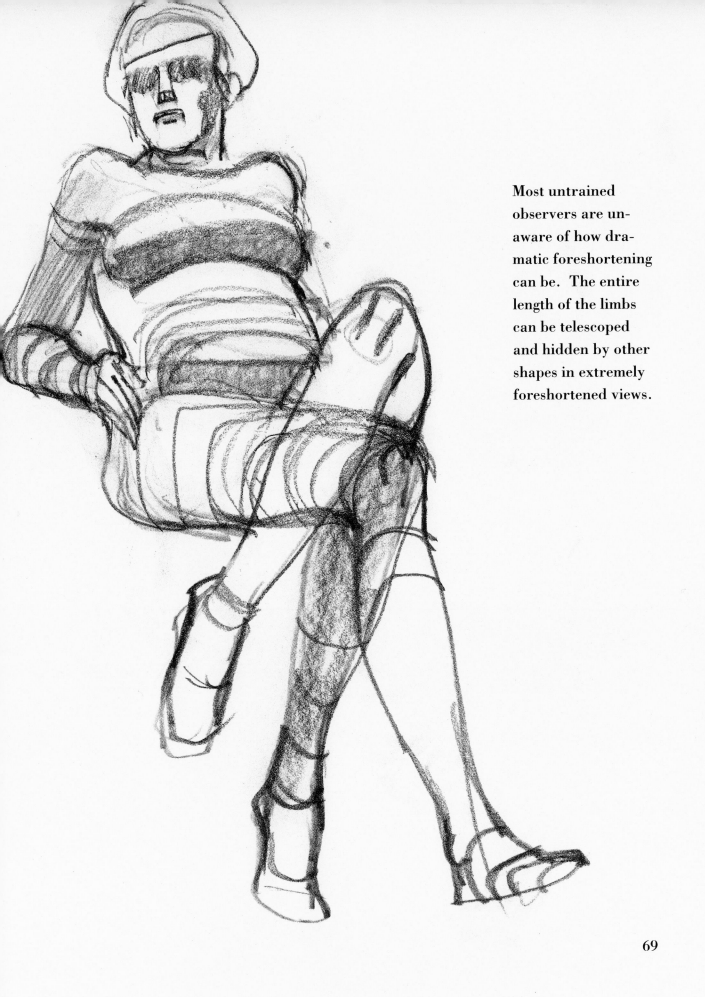

Most untrained
observers are un-
aware of how dra-
matic foreshortening
can be. The entire
length of the limbs
can be telescoped
and hidden by other
shapes in extremely
foreshortened views.

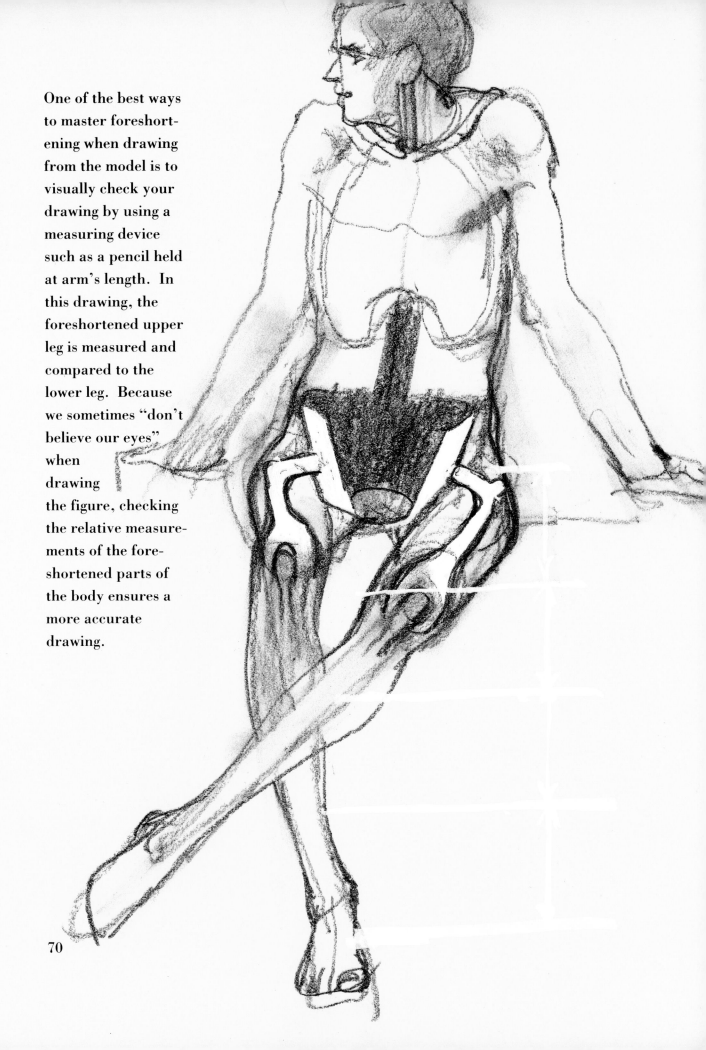

One of the best ways
to master foreshort-
ening when drawing
from the model is to
visually check your
drawing by using a
measuring device
such as a pencil held
at arm's length. In
this drawing, the
foreshortened upper
leg is measured and
compared to the
lower leg. Because
we sometimes "don't
believe our eyes"
when
drawing
the figure, checking
the relative measure-
ments of the fore-
shortened parts of
the body ensures a
more accurate
drawing.

70

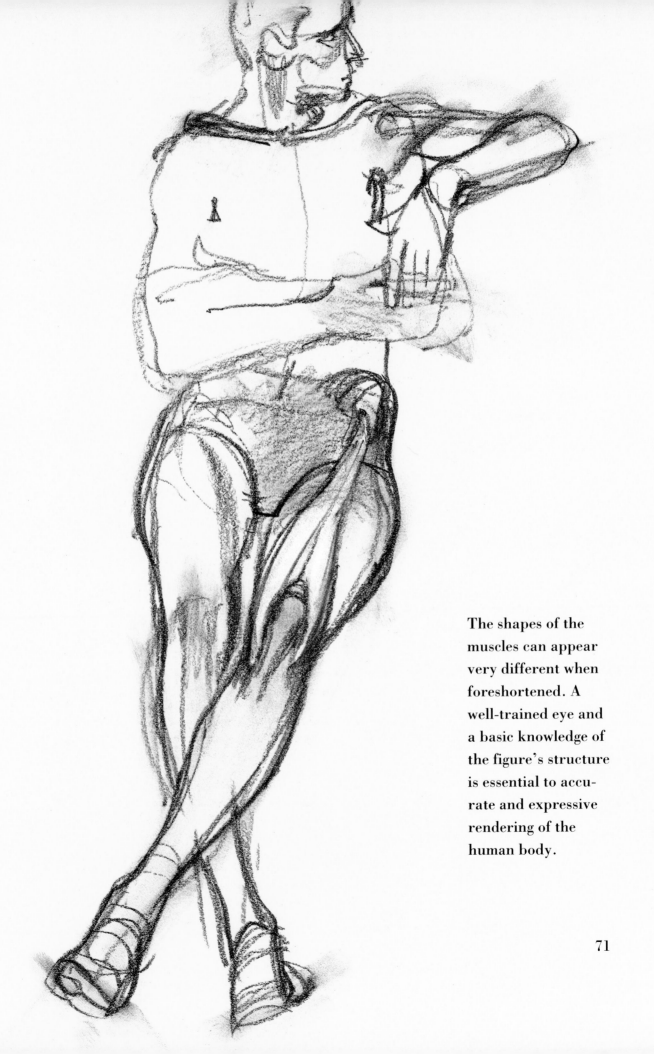

The shapes of the
muscles can appear
very different when
foreshortened. A
well-trained eye and
a basic knowledge of
the figure's structure
is essential to accu-
rate and expressive
rendering of the
human body.

71

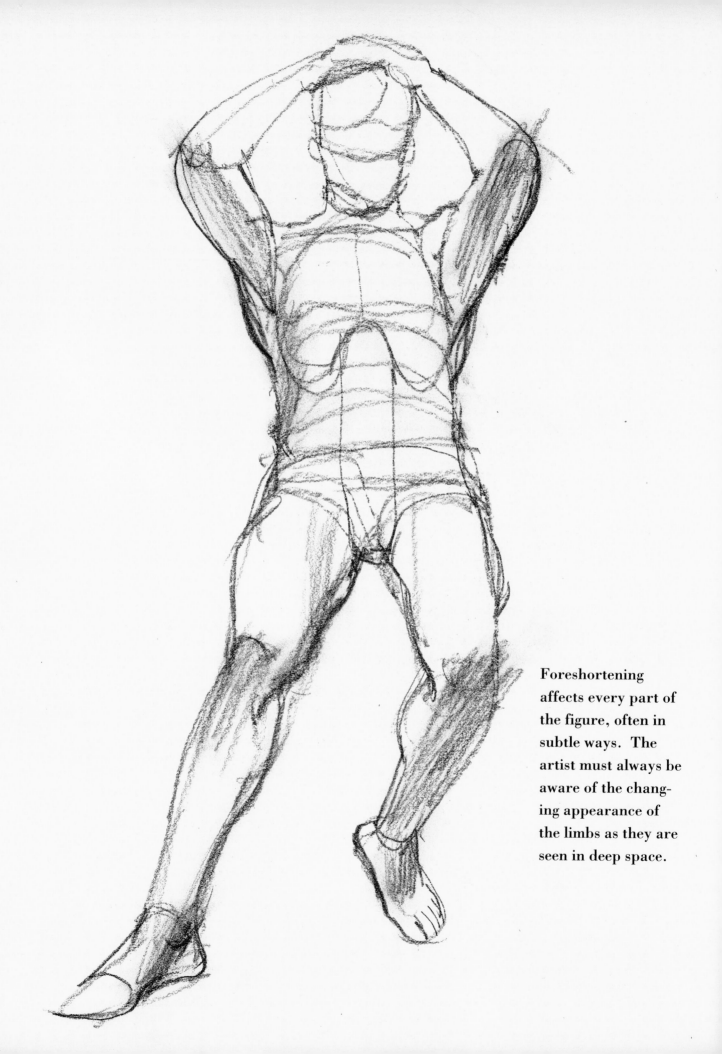

Foreshortening affects every part of the figure, often in subtle ways. The artist must always be aware of the changing appearance of the limbs as they are seen in deep space.

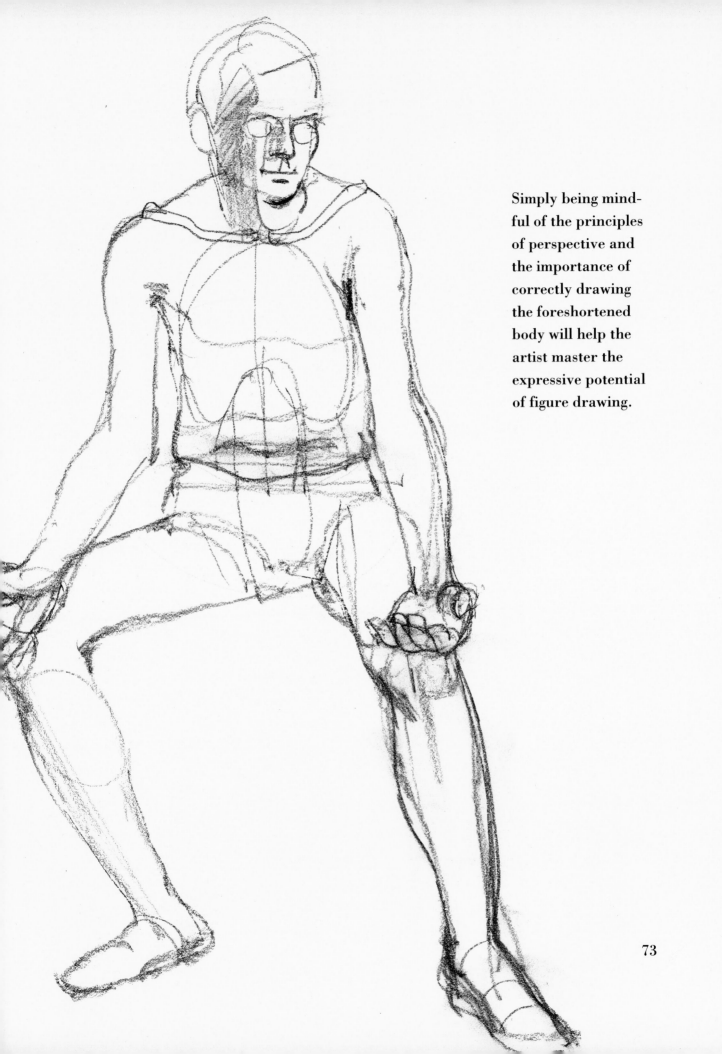

Simply being mind-
ful of the principles
of perspective and
the importance of
correctly drawing
the foreshortened
body will help the
artist master the
expressive potential
of figure drawing.

73

THE HEAD

The skull is a protective shell for the brain and eyes and provides essential openings through which food and air are taken in. The protective area for the eyes consists of the brow, the bridge of the nose, the cheekbones, eyebrows, eyelids and eyelashes. The nose can be thought of as a covered filter with holes for intake of air. The mouth takes in solids and is designed for a more obviously mechanical intake process. The ear resembles a seashell and is perfectly suited for funneling soundwaves to the inner ear.

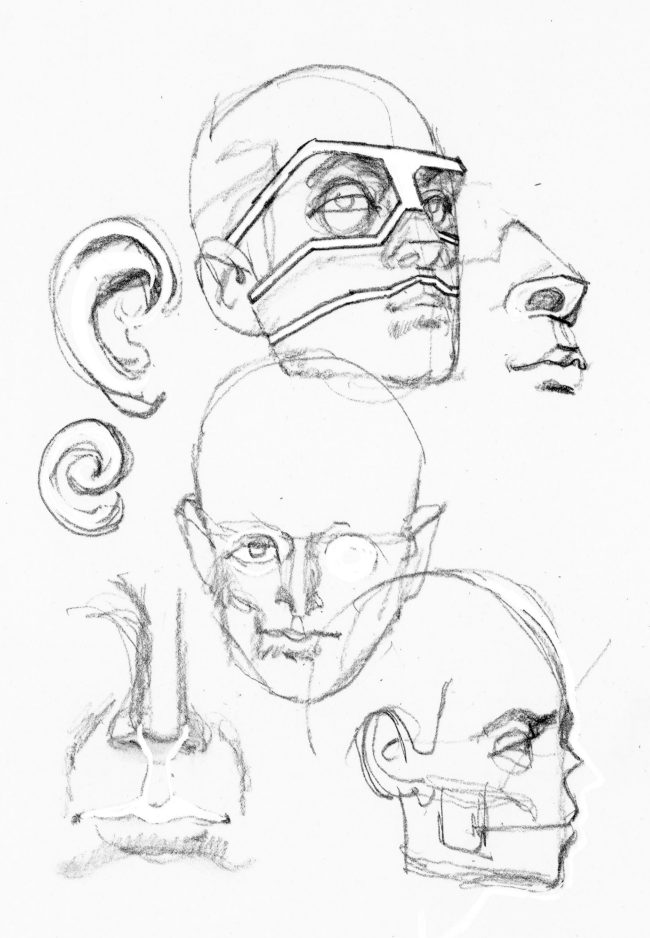

The mouth is really
an opening in the
flesh formed by the
combination of two
separate bones, the
skull and the jaw-
bone. The mouth is
surrounded by
numerous small
muscles. The draw-
ings illustrate how
the upper lip joins
the base of the strip
of flesh between the
nostrils. The top lip
is divided into three
muscular areas.
The lower lip is
composed of one
larger muscular
area.

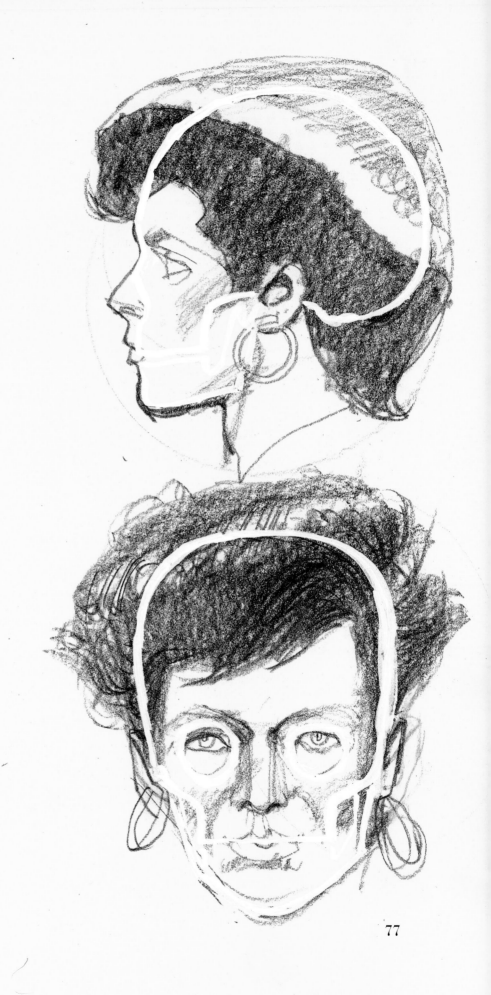

The underlying struc-
ture of the skull shapes
the facial features.
Notice the relative size
of the face to the bulk
of the whole head and
hair. One common
mistake is to over-
estimate the size of the
face in relationship to
the rest of the head.

77

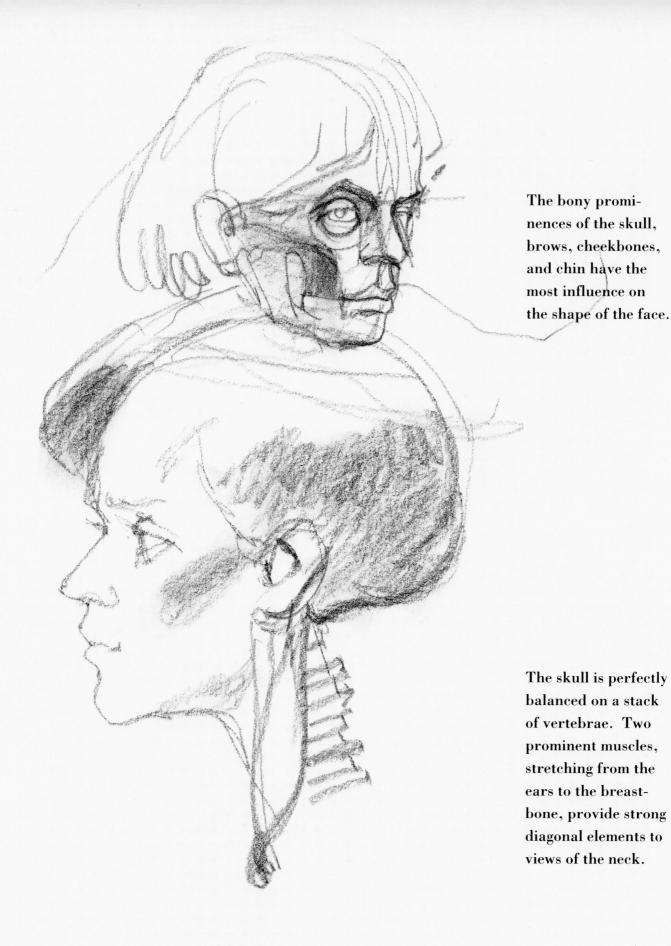

The bony promi-
nences of the skull,
brows, cheekbones,
and chin have the
most influence on
the shape of the face.

The skull is perfectly
balanced on a stack
of vertebrae. Two
prominent muscles,
stretching from the
ears to the breast-
bone, provide strong
diagonal elements to
views of the neck.

78

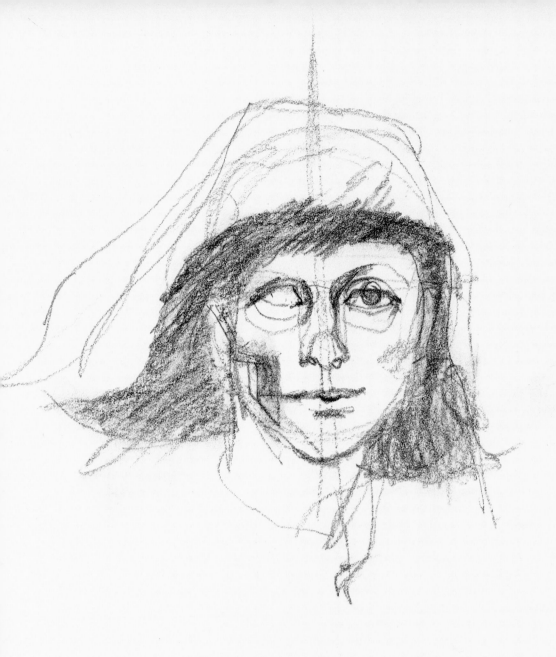

The brows and the
cheekbones create a
protective rim around
the eyeballs in their
sockets. The cheek-
bone forms a kind of
overhanging balcony
beneath which the
jawbone is located.

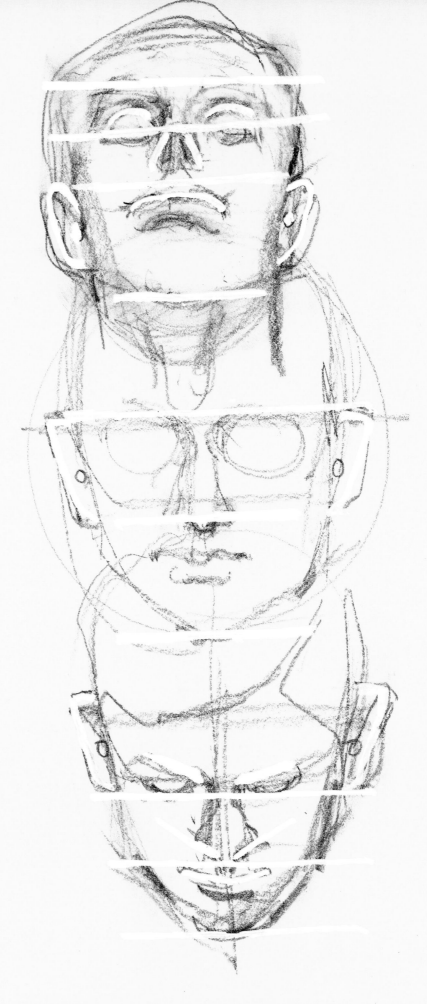

The features can be located on the ovoid shape of the head by using a few guidelines. Seen from a straight-on front view, the brow, bottom of the nose, and bottom of the chin divide the face into equal parts. The ears are the same length as the distance between the brows and the bottom of the nose. When the head is tilted up or down, the features take on a different contour, revealing the curvature of the face.

80

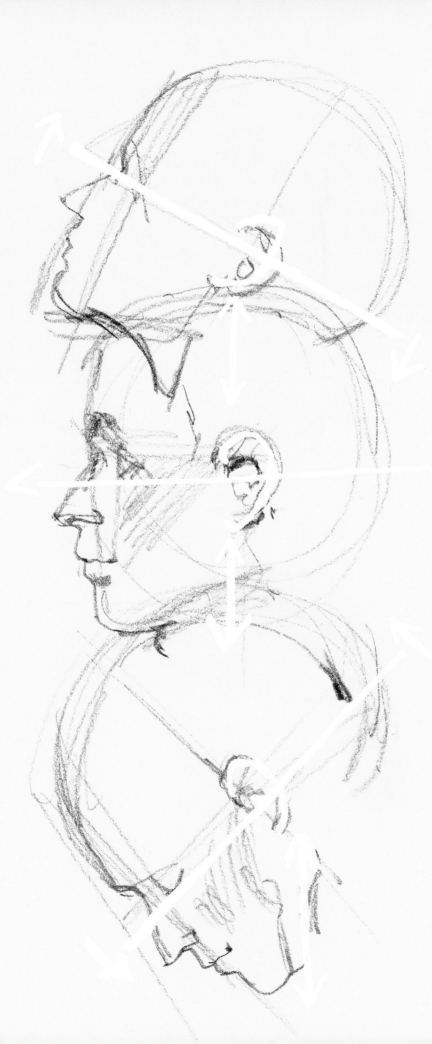

The skull tilts on the spine as if it rested on an axle passing through the ear. When the face is turned upward, the ear appears to be below the midline; when the face is turned downward, the ear appears to be above the midline.

Hair should be treated as having the same bulk and form as any other part of the human figure. It has shape and form and needs to be given as much depth and volume. Hair should only be added once the skull has been clearly indicated.

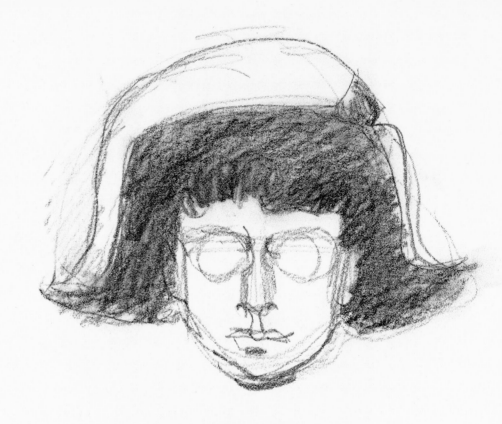

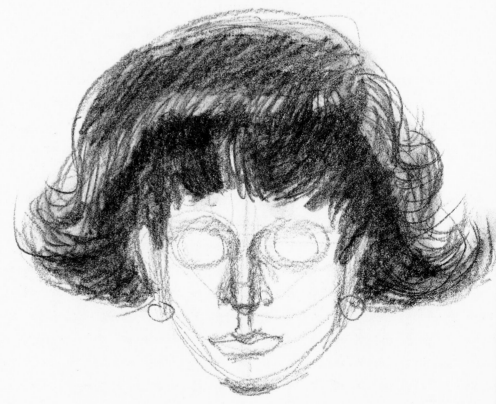

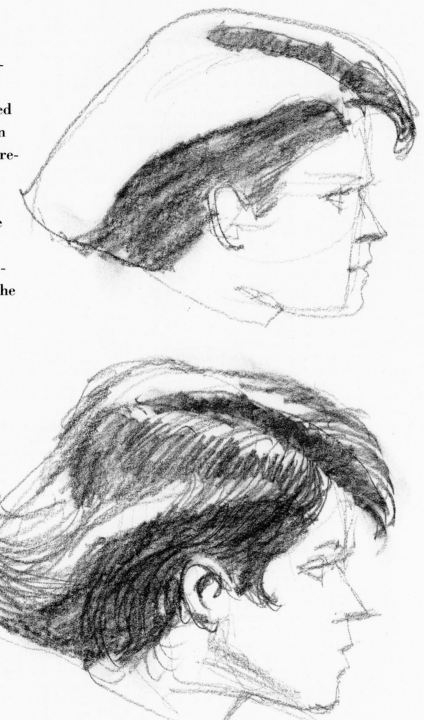

inimal applica-
of texture is
icient, if applied
ightfully and in
mony with the re-
rements of the
position. The
wings illustrate
bulk, volume
subtle applica-
of texture to the
r.

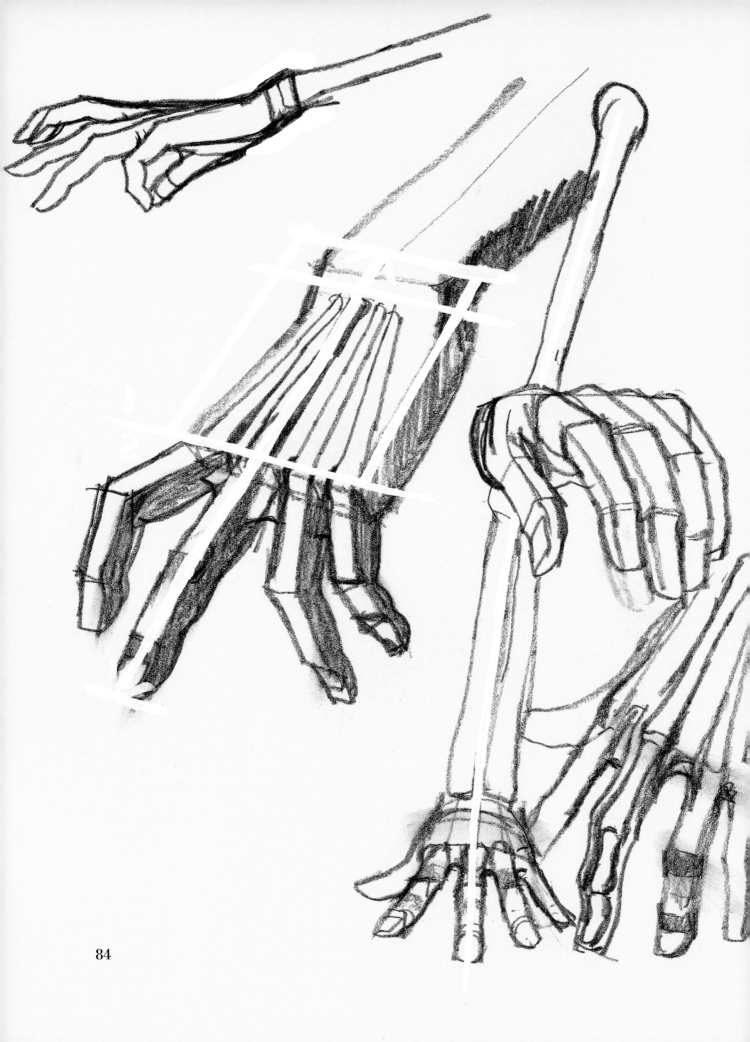

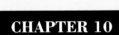

HANDS & FEET

Our hands and feet are distinctively human features. The structure of our hands makes the use of tools possible while our feet are designed for our uniquely human upright stance.

On the male, the "web" between the fingers comes as far as halfway between the knuckle and the first joint of each finger. The female's web does not extend as far toward the first joint, which creates the illusion that the fingers are longer.

In terms of proportion, the hand is twice as long as it is wide. The palm is square. The knuckle of the middle finger is halfway between its tip and the wrist. The other fingers vary in length, and it's helpful to think of them as together forming the shape of a mitten.

To understand the foot, think of it as a flexible arch, an architecture designed primarily for absorbing shocks and bearing exceptional weights securely. The toes are pads that extend the foot's base, that compensate for our balance changes, and that provide traction as we move.

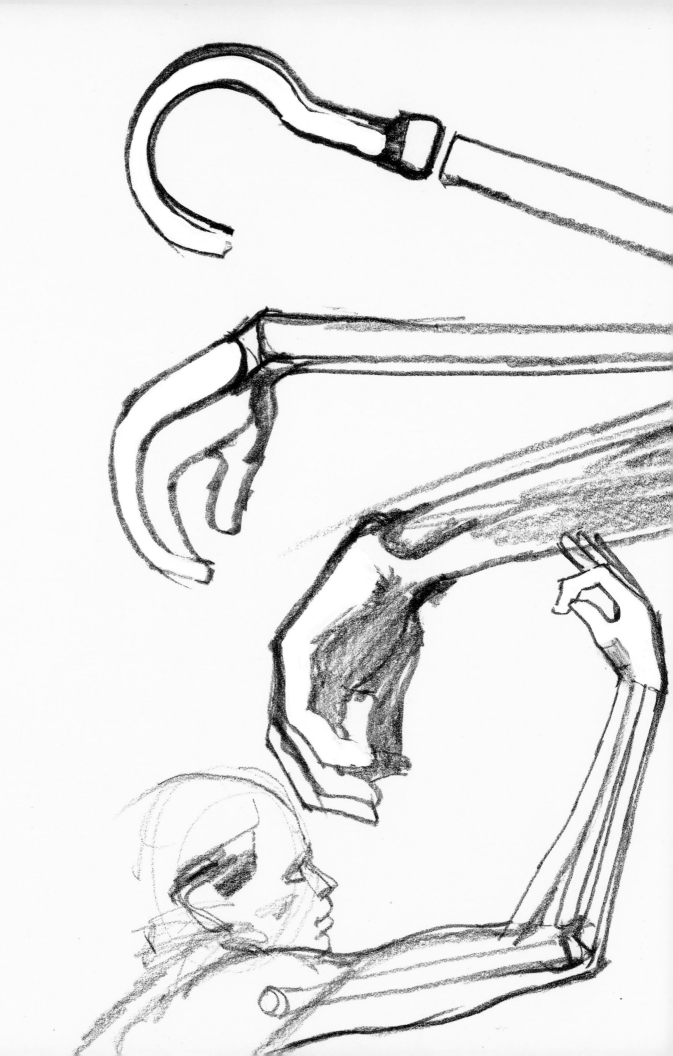

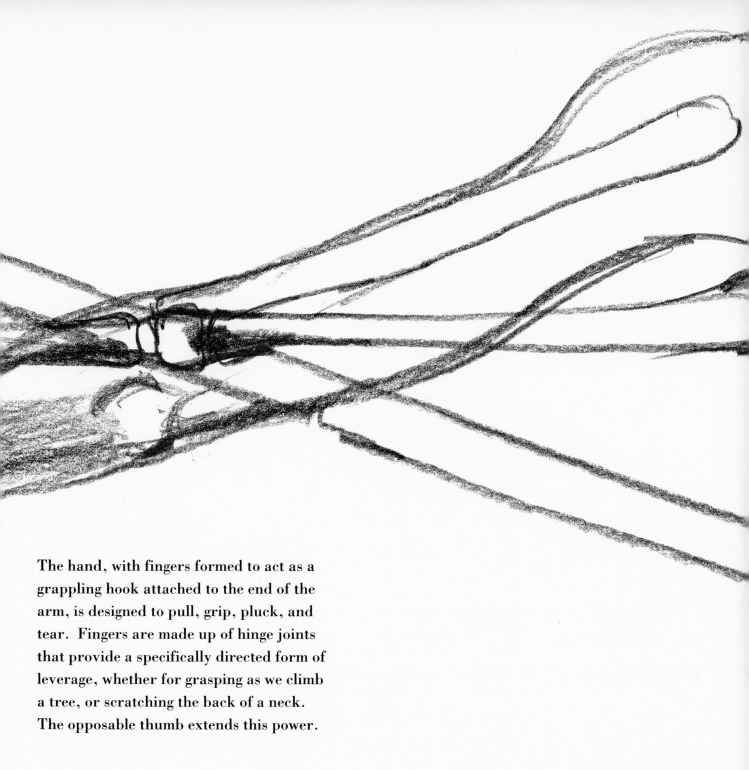

The hand, with fingers formed to act as a
grappling hook attached to the end of the
arm, is designed to pull, grip, pluck, and
tear. Fingers are made up of hinge joints
that provide a specifically directed form of
leverage, whether for grasping as we climb
a tree, or scratching the back of a neck.
The opposable thumb extends this power.

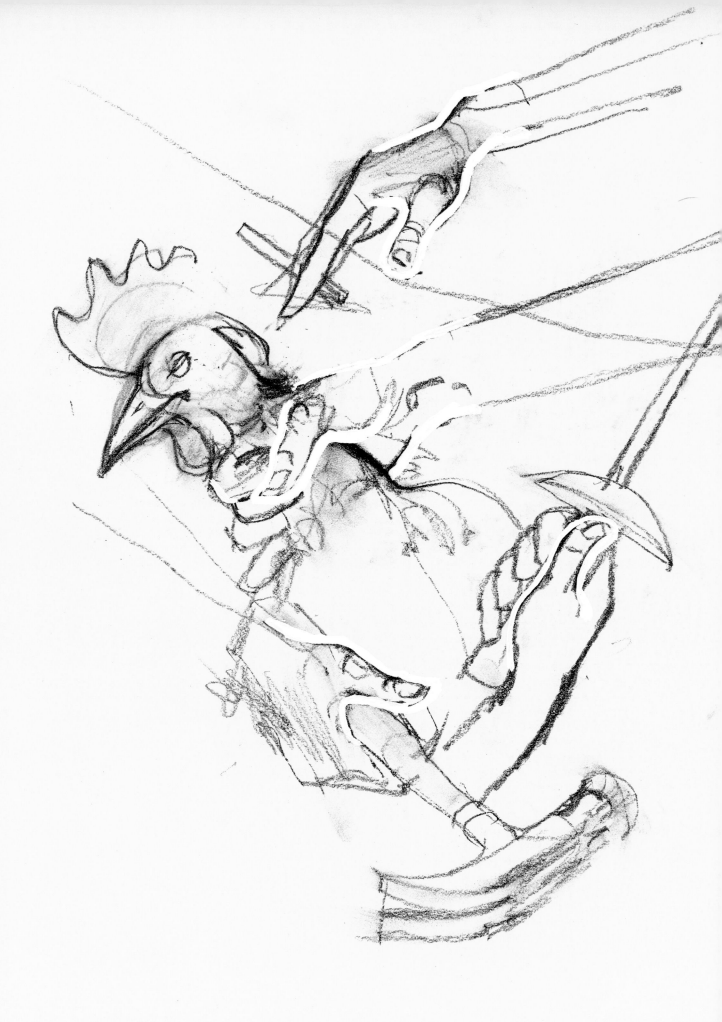

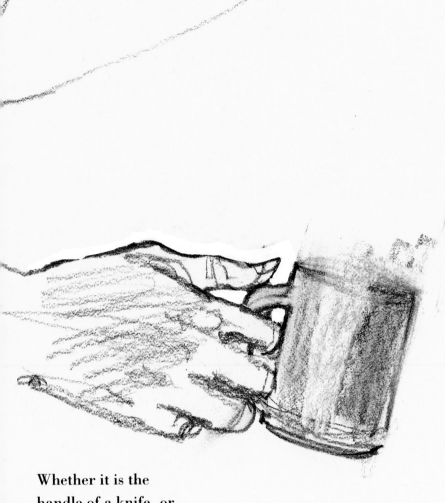

Whether it is the
handle of a knife, or
the throat of a
rooster, the thumb
serves to enclose the
hand's prey in a sure
grasp. If thought of
this way, the hands
will become much
easier for the artist
to draw, and will no
longer need to be
hidden in pockets
and behind clothing.

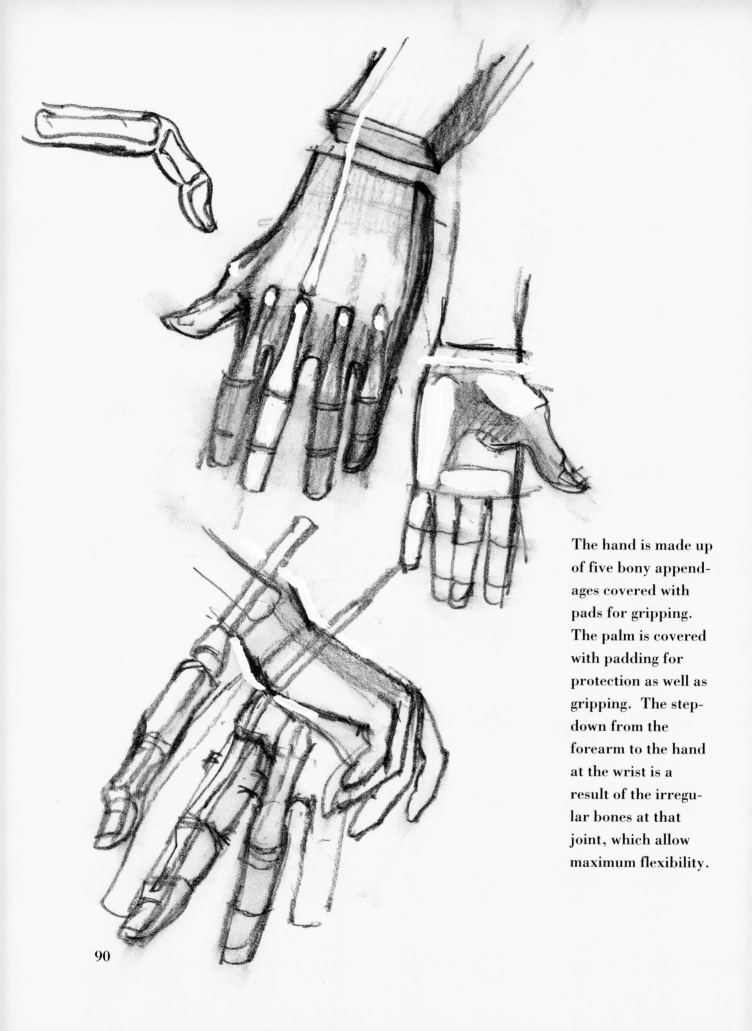

The hand is made up
of five bony append-
ages covered with
pads for gripping.
The palm is covered
with padding for
protection as well as
gripping. The step-
down from the
forearm to the hand
at the wrist is a
result of the irregu-
lar bones at that
joint, which allow
maximum flexibility.

90

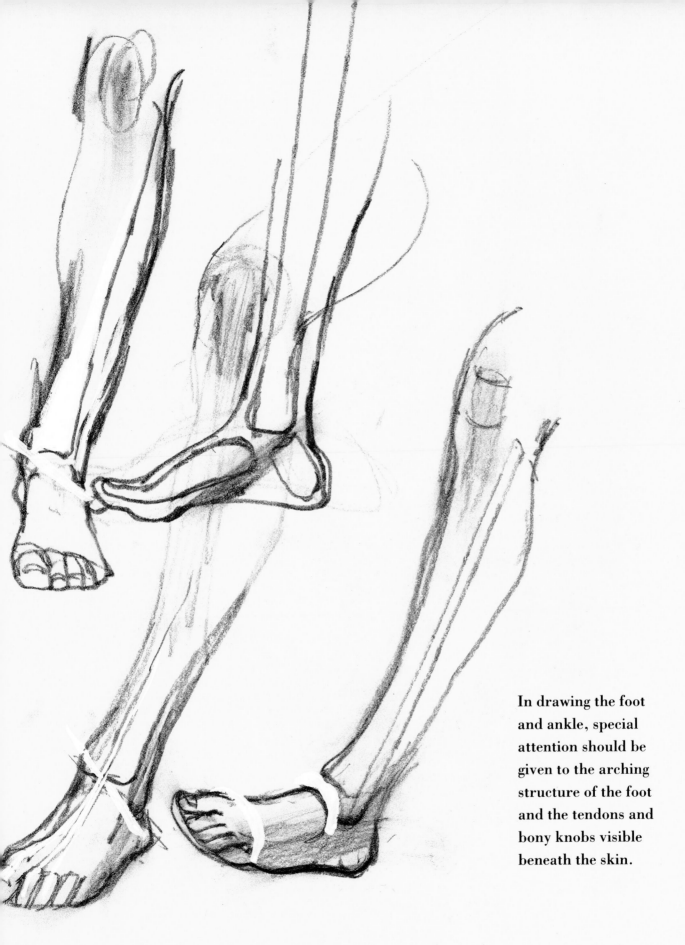

In drawing the foot
and ankle, special
attention should be
given to the arching
structure of the foot
and the tendons and
bony knobs visible
beneath the skin.

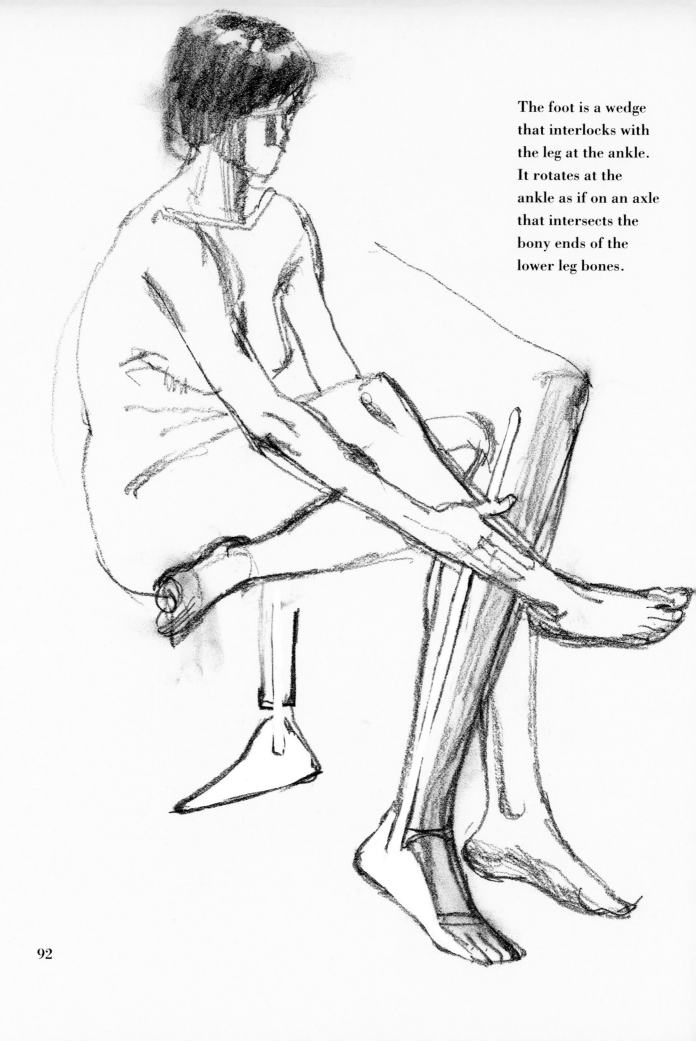

The foot is a wedge
that interlocks with
the leg at the ankle.
It rotates at the
ankle as if on an axle
that intersects the
bony ends of the
lower leg bones.

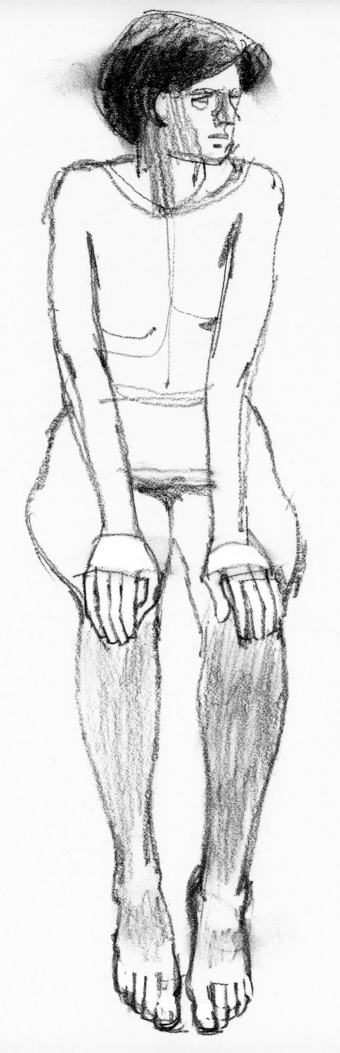

Although the hands and feet have very different functions, there is an obvious similarity in structure. At one time, the big toe served as a "grabber" like our thumb, but its function evolved since we began to stand erect.

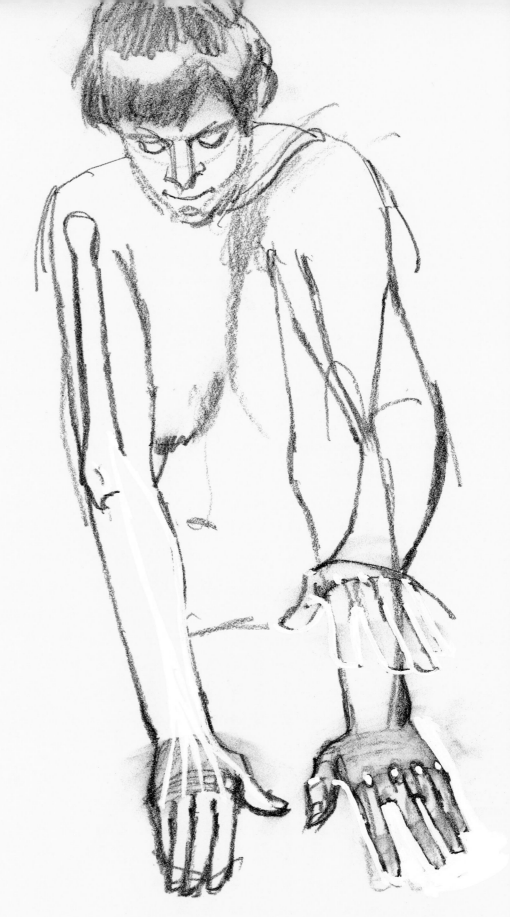

The fingers are
operated by muscles
located in the fore-
arm. These muscles
account for much of
the forearm's mass
near the elbow. The
knuckles act as
pulleys for the ten-
dons that attach the
fingers to the
muscles that work
them.

94

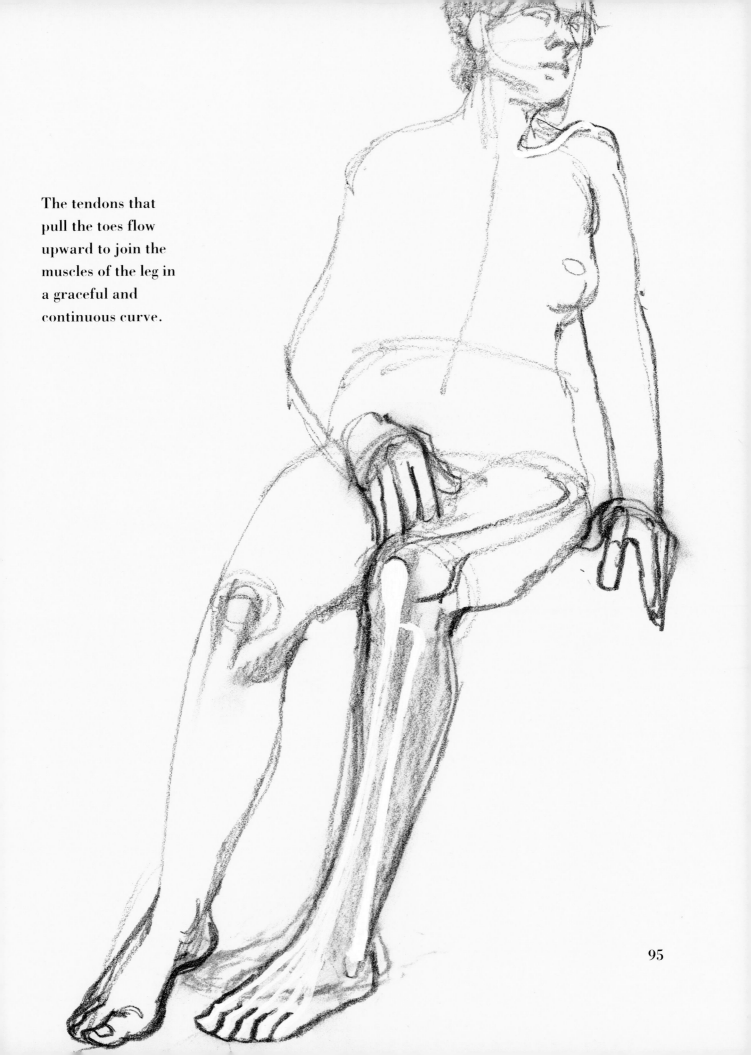

The tendons that
pull the toes flow
upward to join the
muscles of the leg in
a graceful and
continuous curve.

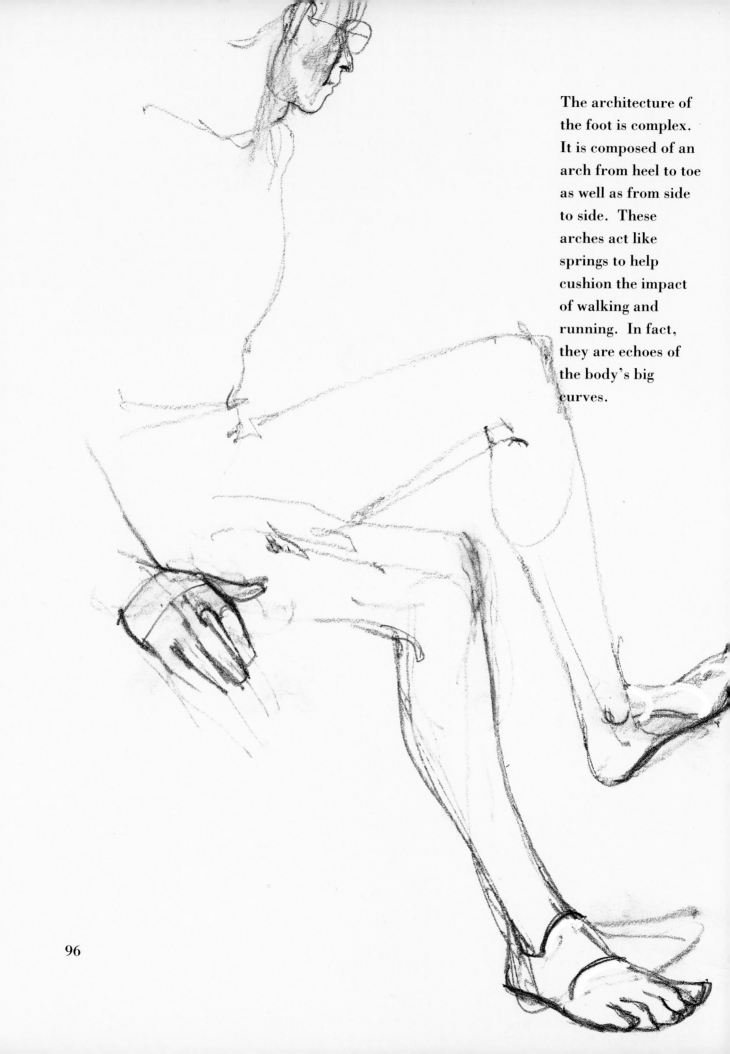

The architecture of
the foot is complex.
It is composed of an
arch from heel to toe
as well as from side
to side. These
arches act like
springs to help
cushion the impact
of walking and
running. In fact,
they are echoes of
the body's big
curves.

96

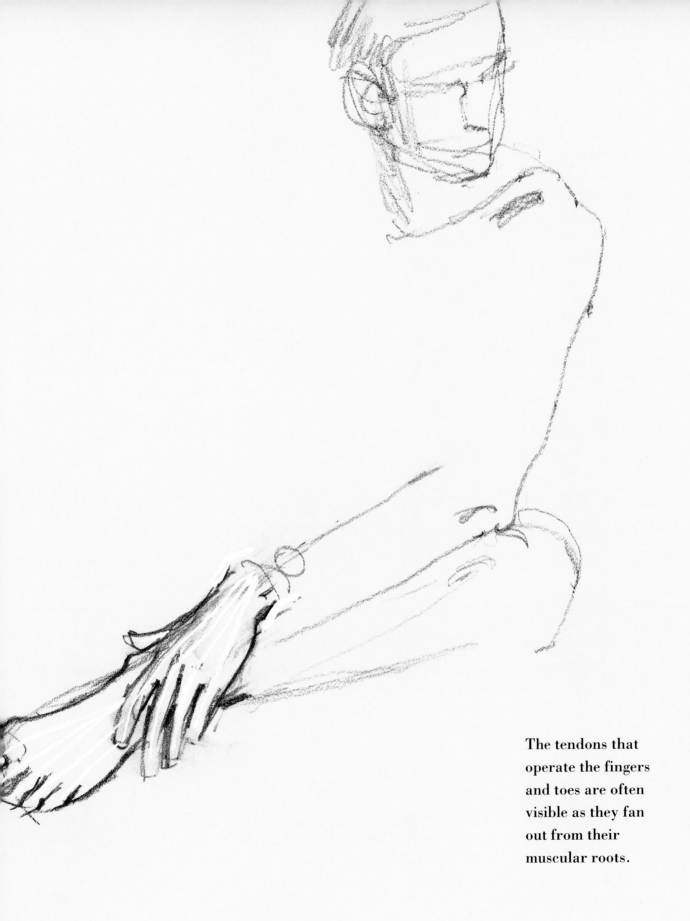

The tendons that
operate the fingers
and toes are often
visible as they fan
out from their
muscular roots.

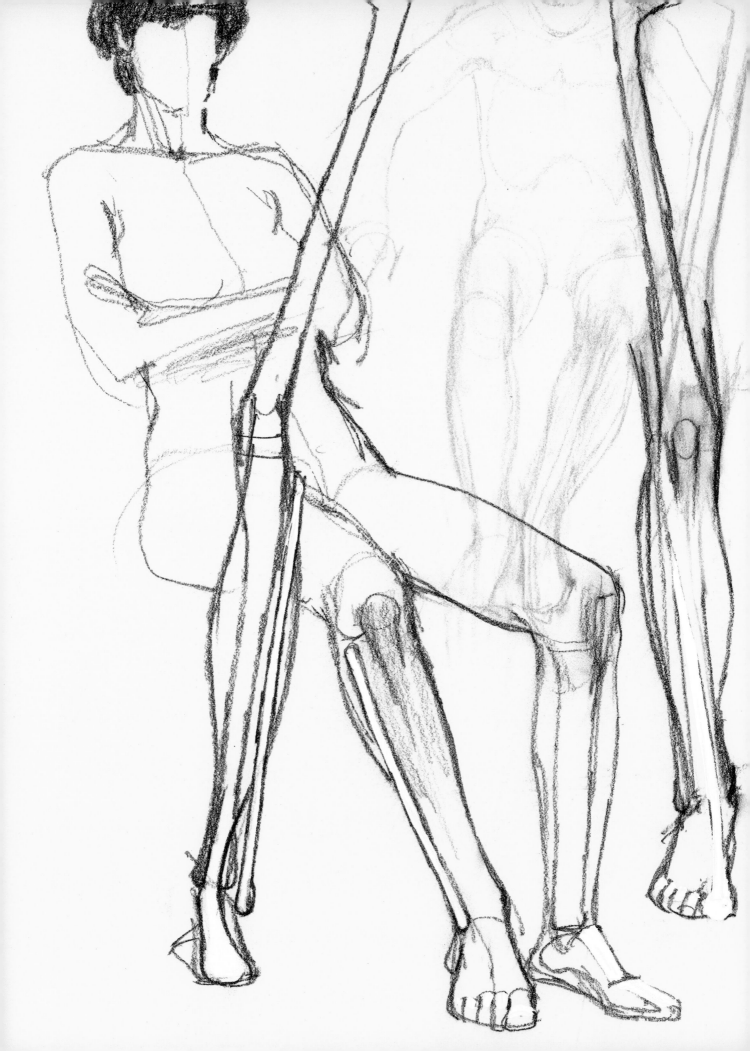

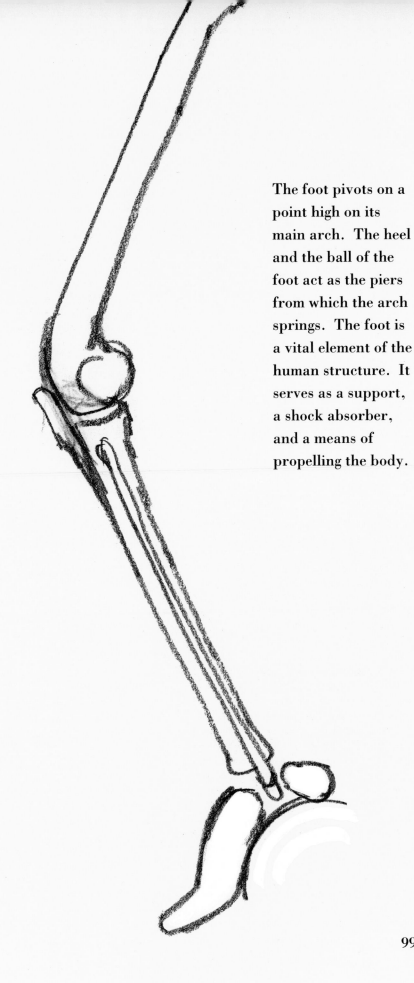

The foot pivots on a point high on its main arch. The heel and the ball of the foot act as the piers from which the arch springs. The foot is a vital element of the human structure. It serves as a support, a shock absorber, and a means of propelling the body.

The important structural features of the feet are highlighted in these drawings. The foot itself is wedge shaped, with the toes arranged like a step-down at the narrow end. Notice how the ankle angles the foot in a slightly different direction from the lower leg.

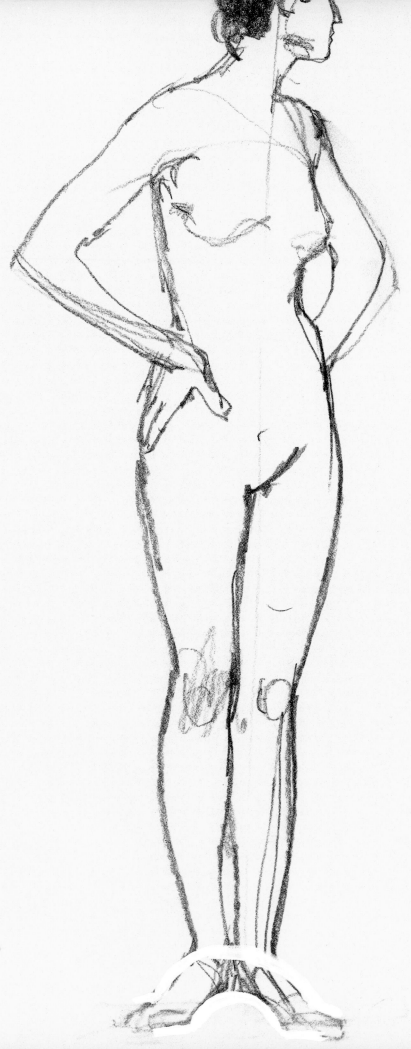

When the feet are placed heel to heel with the toes pointing outward, as in first position in ballet, the arches of the feet form a greater arch to stabilize and support the weight of the body.

100

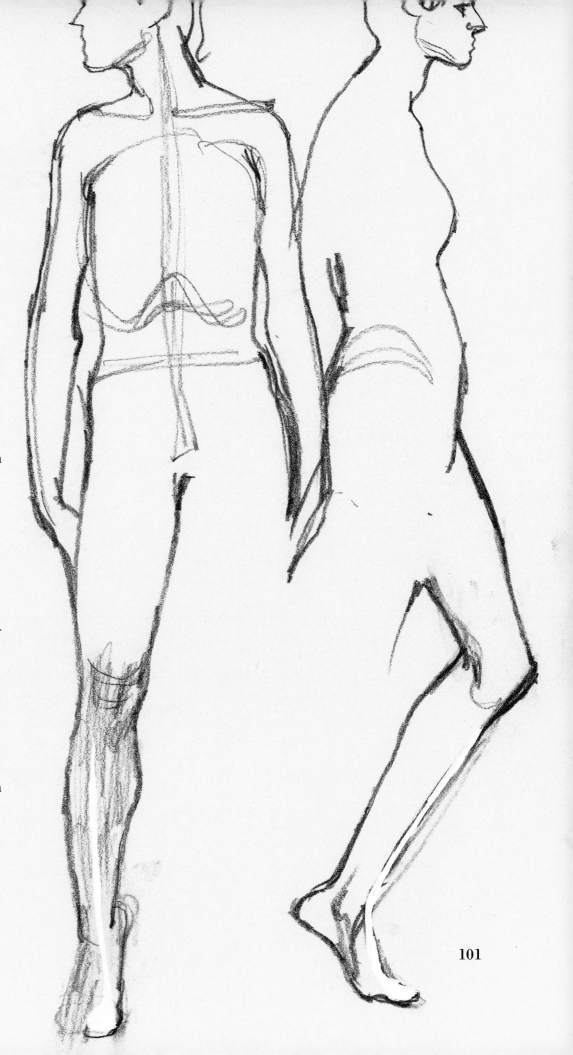

The big toe is a critical member of the body. Although small in relation to the body as a whole, and generally overlooked in drawing, the big toes serve in two heroic capacities:

1. They balance our bodies throughout our entire range of activities. Without them we would have severe difficulty with such motions as walking, standing, and rising from a seat.

2. Simultaneously, they act as "brakes" that halt our feet immediately and effectively when, while walking or running, we come to a stop. They push off when we get moving again and provide traction as we go.

101

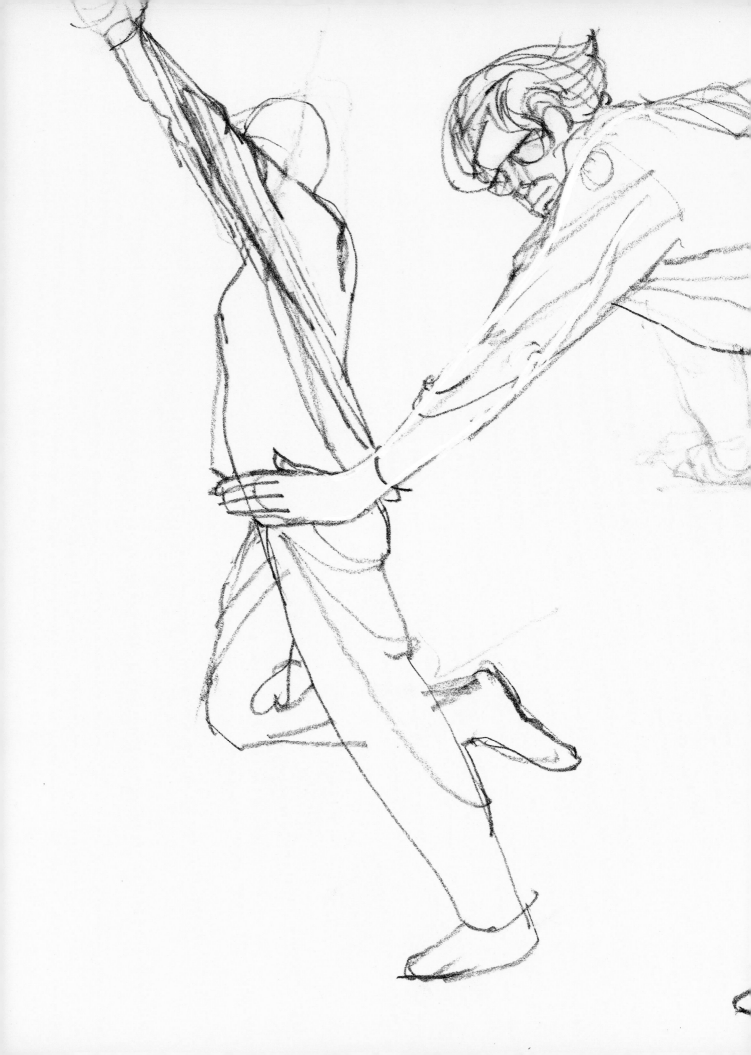

CHAPTER 11

GESTURES & CLOTHING

To suggest movement in a clothed body, the artist must carefully observe and select not only the major stress points, where the material is being pulled from one point to another, but also the unstressed areas where the material is wrinkled and folded. Wherever clothing follows the body's contours is an opportunity for the artist to emphasize the figure's movement beneath the covering, in order to be especially expressive and convincing. The secret lies in selecting only the main folds and lines that tell the story and eliminating all others.

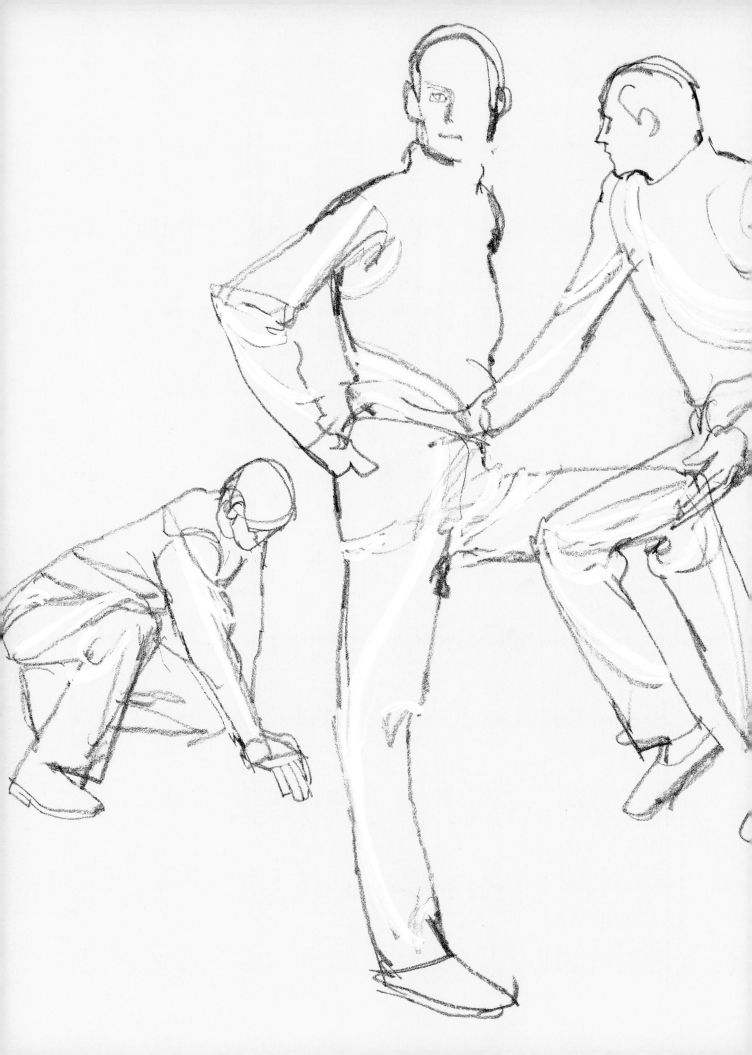

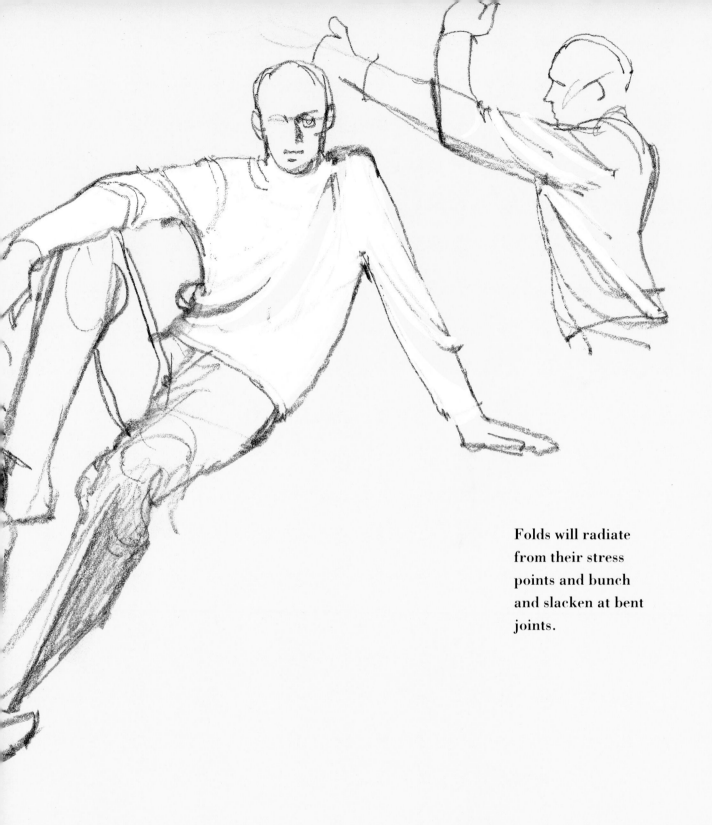

Folds will radiate
from their stress
points and bunch
and slacken at bent
joints.

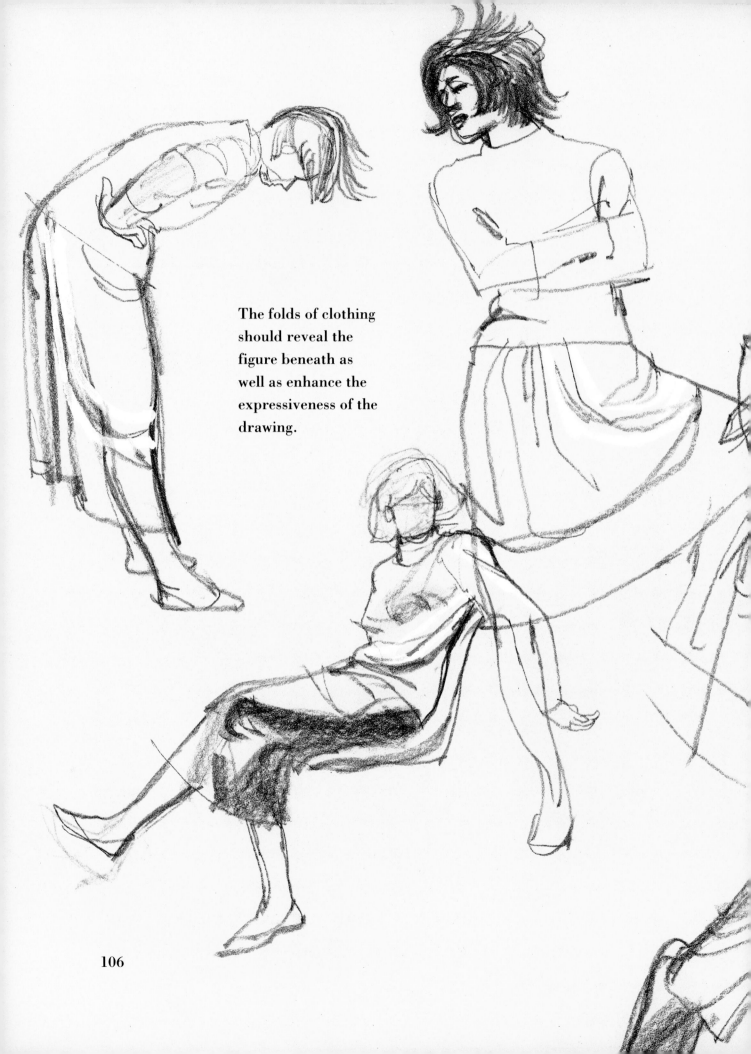

The folds of clothing
should reveal the
figure beneath as
well as enhance the
expressiveness of the
drawing.

106

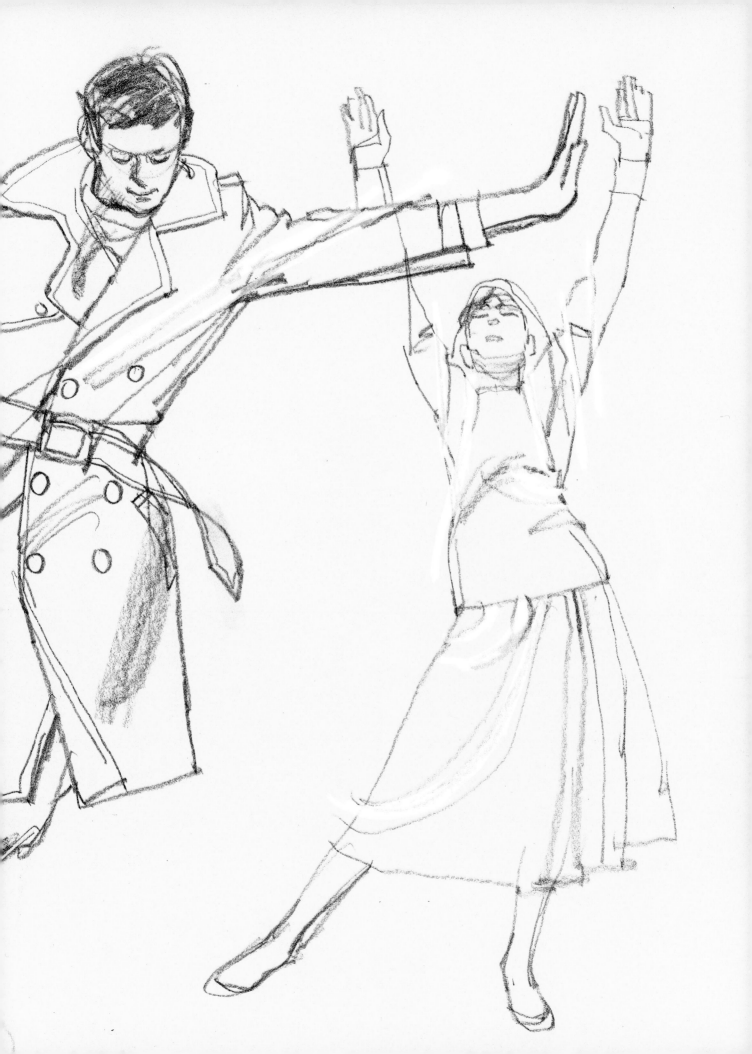

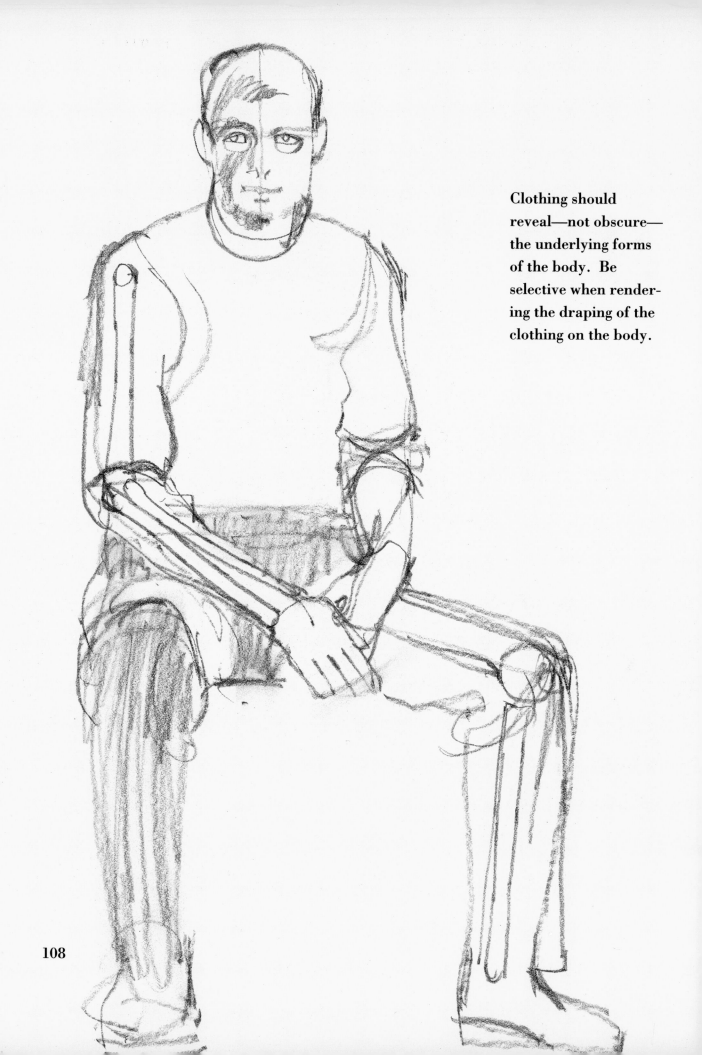

Clothing should
reveal—not obscure—
the underlying forms
of the body. Be
selective when render-
ing the draping of the
clothing on the body.

108

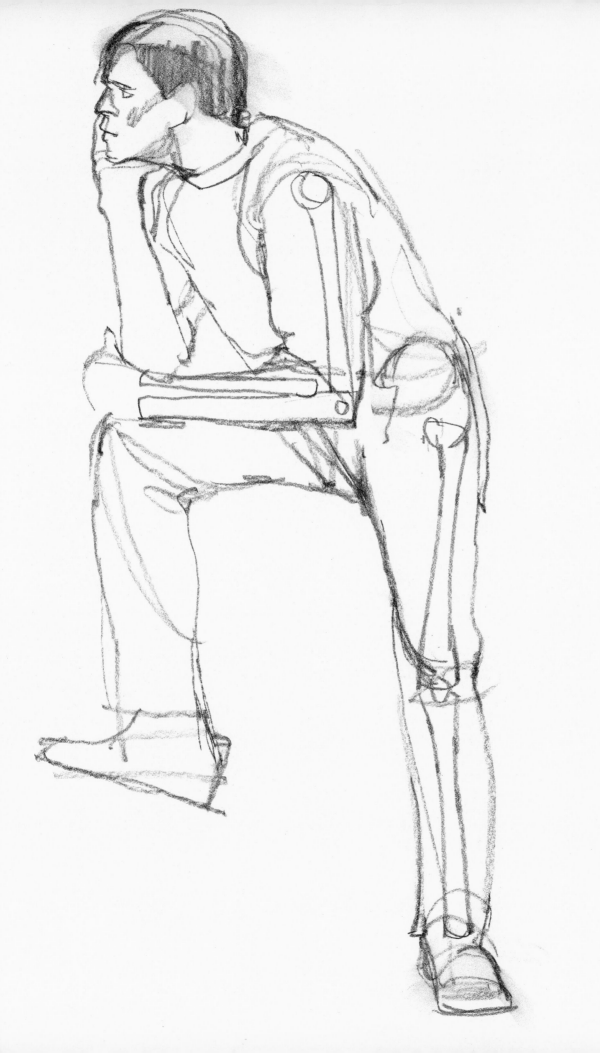

CONCLUSION

I wrote this book for two reasons: the first, of course, is to show how to depict the magnificent example of design and function that is the human figure. The other is to help artists "see" not only the human form, but everything they draw, as a whole greater than its parts. To see beyond the details to the underlying unity of the human structure is the key to truly expressive figure drawing.

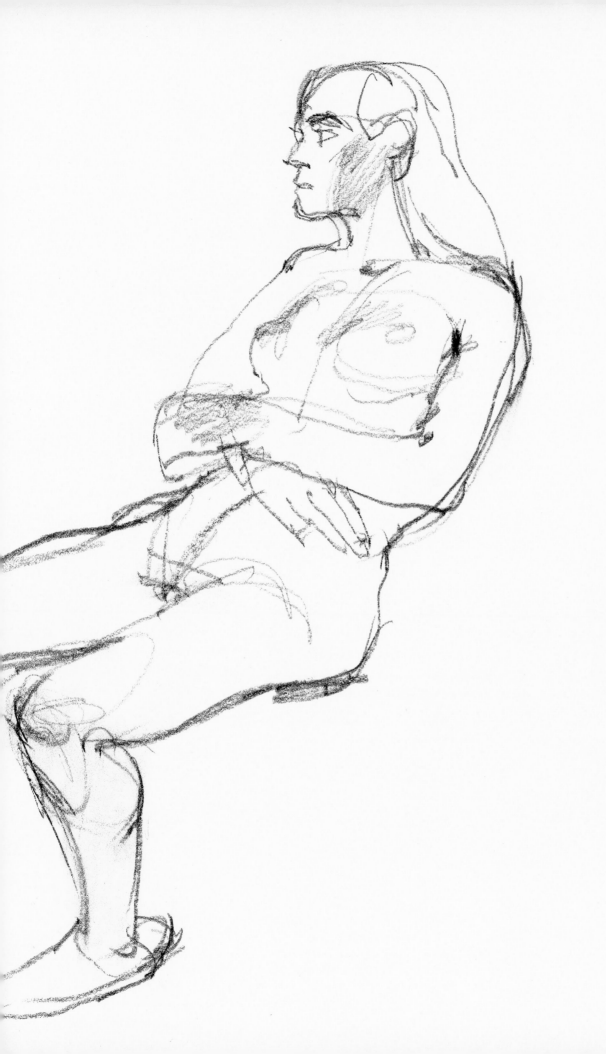

AFTERWORD

My approach to drawing the human form began in
1947 at the Jepson Art Institute of Los Angeles.
Herbert Jepson taught the simplified muscle and
bone structure of the human figure, describing why
our bodies are shaped as they are. Two years later,
I studied under Wallace Rosenbauer of the Kansas
City Art Institute who presented a figure class de-
scribing the design, structure and function of the
human system.

My only other reference was Victor Perard's
Anatomy and Drawing, recently republished by
Bonanza Books.

I have combined these three sources to produce
this book describing a simple, practical method of
depicting the human form.

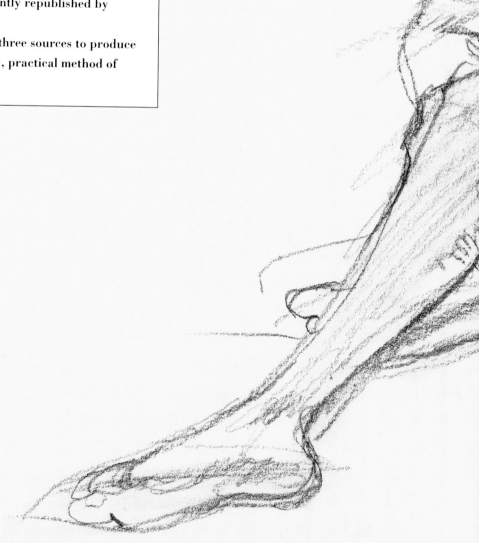

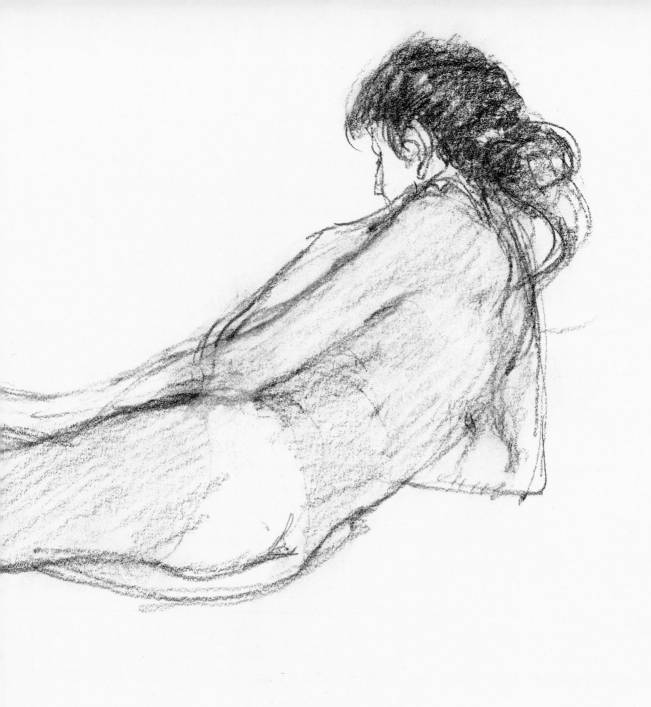

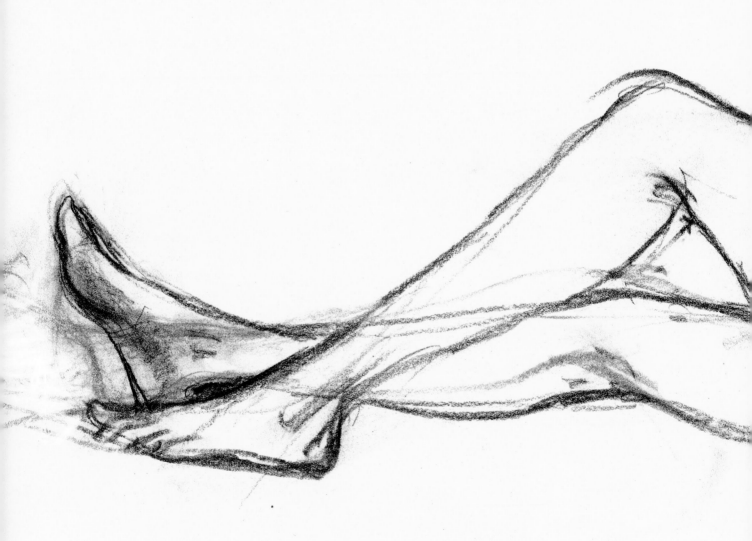

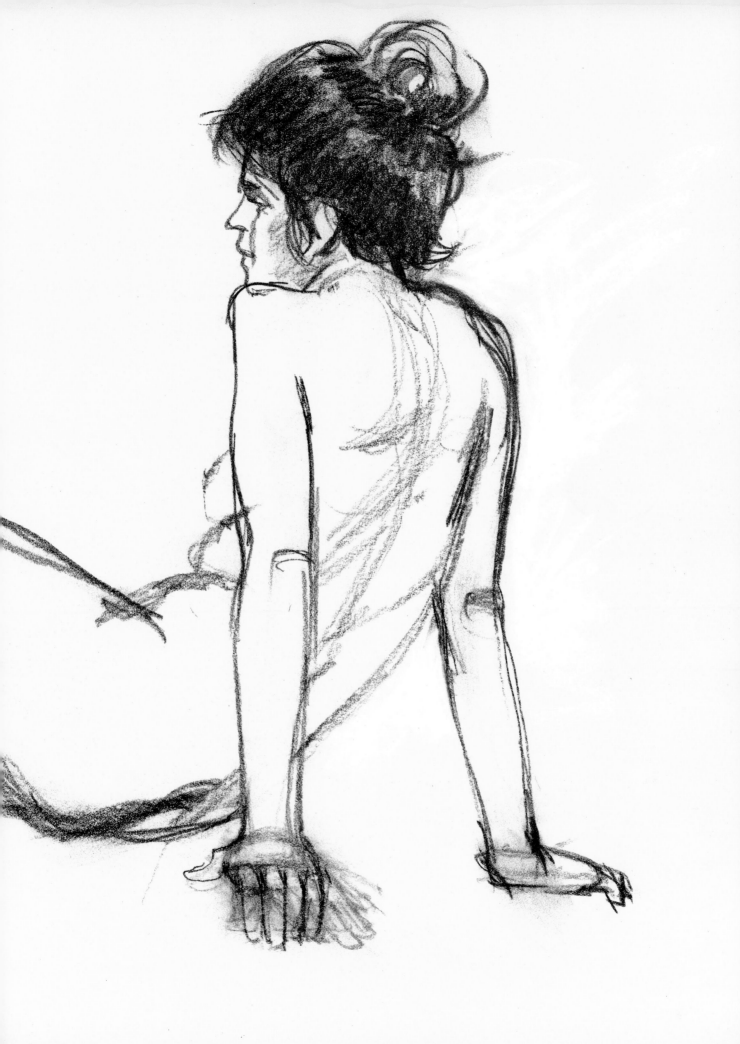